MAKE FANTASTIC HOME VIDEOS

W9-CPE-781

John Fuller

AMHERST MEDIA, INC. ■ AMHERST, NEW YORK

Published by:
 Amherst Media, Inc.
 418 Homecrest Dr.
 Amherst, NY 14226
 Fax: 716-874-4508

Publisher: Craig Alesse
Editor/Designer: Richard Lynch
Assistant Editors: Michael Powers
 Frances Hagen
Illustrations: Erv Zackman

Library of Congress Catalog Card Number: 95-79715
ISBN 0-936262-37-0

10 9 8 7 6 5 4 3 2 1

Printed in the United States of America

Table of Contents

Preface

I can remember the first time I put a motion picture camera up to my eye like it was yesterday. It was in 1964, shortly after I was hired as a news reporter for a small television station in Moline, Illinois. I had to go out and dig up the facts, write the stories, shoot the film, process it and, finally, edit it.

In those days, we used a spring-driven Bell & Howell camera that sounded like a coffee grinder as it ripped through a hundred feet of film in two and a half minutes. Instead of a zoom lens, as all camcorders and news cameras have today, it had three fixed-focal-length lenses on a rotating turret.

Although I knew something about picture composition from working with still cameras, the switch from 35mm stills to 16mm motion pictures created a real challenge. Each assignment presented new problems that had to be overcome which forced me to

try new approaches and ideas. Some worked and some didn't. I learned from success, as well as failures.

When technology developed new equipment, I switched from film to videotape, and today serve on the news mini-cam staff of WXYZ-TV in Detroit.

Getting started on the right foot, with the help of some experts, was my key to a successful professional career. You deserve the opportunity to start off on the right foot, too. When you bought your camcorder, the salesman probably said, "All you have to do is point and shoot," and left it at that. He didn't have the time, and possibly the knowledge, to help you. The instruction book that came with your camcorder didn't offer much help either. It explained the workings of all the buttons and knobs, but nothing about how to make a good picture.

Making Fantastic Home Videos picks up where the manufacturer's instruction book leaves off. This book has already sold 20,000 copies under the title, *Prescription for Better Home Video Movies* (Price Stern Sloan, Publishers). From it you'll learn many of the shooting techniques I've learned and have used every working day over the past 30 years as a television news cameraman. In this new edition, I've moved, dropped, and added chapters to better explain and place more emphasis on the things you need to know.

You'll find the suggestions and techniques I explain in this book easy to understand and put into use. These suggestions will solve the basic problems that face not just the new camcorder owner, but every amateur videomaker.

The time you spend reading this book and working with your camcorder may not lead you to a new career. But, it will help you make better, more entertaining, exciting, informative, amusing, and technically better home video movies. You've spent a lot of money for your camcorder and you deserve to enjoy the results.

Introduction

You're a Television Expert

You and I are television experts. That's right, all of us are TV experts and I bet you didn't even know it. Not only are we television experts, we're television critics. I can make the claim because I've worked in television for 30 years. You're an expert because you've watched a lot of television over the years. You've watched news, dramatic shows, cartoons, soap operas, movies, and sports events of all kinds, all produced by professionals using state-of-the-art equipment and the latest production techniques.

As a result, you know what you like and you know and can appreciate good quality television. You also know what you don't like and will flip the channel, even turn off the TV, when you don't like the program you're watching. You may not realize what made you change channels, but something in the back of your mind said,

"This is bad television." It may be the acting, it could be the script, or it might even be the technical quality of the picture or the sound.

As TV experts, we clearly see a difference in quality when we switch from professionally-produced television or movies to home videos.

As kids, we all knew what we were in for when grandpa invited the family over to watch his 8mm vacation movies. They were terrible! We had to sit through reel after reel as a noisy old projector cranked out a steady stream of scratchy, jerky, and out-of-focus shots filled with grandma standing in front of Old Faithful or holding up a giant redwood.

Now you're making home videos, not with an old 8mm film camera, but with one of the marvels of the space age: a lightweight, one-piece camera and recorder that makes remarkable pictures in beautiful color with natural sound for an amazingly low cost and you don't have to wait forever for the video to come back from the processor. However, for some reason, your videos still look like grandpa's: shaky and out-of-focus, with your kids standing on the same

spot in front of Old Faithful or holding up the same giant redwood.

You're an Amateur Videomaker, Not a Hollywood Producer

Your home movies were never meant to look like Hollywood productions, but there's no need for them to look as bad as grandpa's films, either. They won't if you follow the suggestions I offer in this book. In fact, this book could be the most used and least expensive accessory you'll ever buy.

This book is for all amateur videomakers. It's for the person who knows nothing about camcorders or shooting movies, and has little ambition beyond making a few simple home videos. It's also for the person who has used an 8mm film camera or a video camera but has never really learned right from wrong, the person who has never been able to figure out why his or her videos don't remotely resemble the shows seen daily on television. It's for the advanced amateur who's looking for that little "something" he or she missed somewhere along the way as well.

Think of your camcorder as you would a piano. You wouldn't expect to sit down and play Tschaikovsky the day the piano is delivered. You'll need lessons and lots and lots of practice. The same goes for your camcorder. Some advice from a professional and some practice will help you improve your ability as a home videomaker.

In shooting TV news, I have to tell a story with my camera, shooting without a script as an event unfolds. And that's the way you want to shoot most of your home videos.

Learn from The Pros

By reading this book and by watching TV, you'll learn from the pros and soon discover right from wrong. With a little practice you should see a big improvement in the quality of your home videos. This book is a prescription for making better home video movies: it's a cure for ailments that other sources, including the camcorder manual, other lengthy and more complex guidebooks, and the salesman, failed to cure.

Take note of the ideas presented in this book as you watch TV. For example, tape a news magazine program and study it over and over. Make notes, listing each shot and indicating whether it's a wide shot, medium shot, or tight shot, and whether a pan or zoom was used. Compare the list notes with the list made from your last vacation video. I promise you the comparison will be revealing if not shocking as they'll be nothing alike.

As you compare your video with TV video and as you read this book:

- You'll see how a slight change in camera position or tilt of the camera, one way or the other, will enhance the framing of the shot.

- You'll discover how one camera can be used to produce a series of shots that look as if they had been taken with two or more cameras.

- You'll see how much better it is to shoot natural action than it is to stage a scene or play director.

- You'll learn that every camera move has a reason and that indiscriminate pans and zooms, for the most part, are to be avoided.

- You'll see how to use a little extra light to bring out the color in the rosy cheeks of a child.

- You'll learn that timing is as important when shooting action with a "motion picture" camera as it is when "freezing" action with a still camera.

- You'll even rediscover that patience is a virtue, that it's better to wait for the right shot than to simply shoot everything that moves.

- You'll find that sound is as important as the picture and often needs special attention so your sound will consist of more than someone spouting that all-too-familiar greeting of "Hi Mom!"

When you add it all up, you'll realize that five minutes of well-shot vacation video is much more meaningful and enjoyable to watch than two hours of bad vacation videos.

As you try to emulate what you see on TV, don't be discouraged if it takes a while to achieve the results you want. Remember, the pro whose video you studied didn't get to the top overnight. It took a lot of hard work and practice.

Study this book and practice my techniques but don't leave it on the book shelf when your finished. Keep it with your camcorder so you can refer to it whenever you have a problem while shooting video.

I doubt that you're going to try to re-create "Gone With The Wind," you just want to have a little fun with your camcorder. That won't be difficult if you follow this suggestion: As I explain an idea or technique, use your camcorder to deliberately shoot it the wrong way, and then shoot it the right way.

By doing this you'll immediately see the difference. With a little practice using my techniques, you'll see your home videos improve dramatically.

Chapter One

Your Camcorder — A Memory Machine

I remember the first time I saw someone using a video camera. It was at a backyard pool party not all that long ago. The unit was an awkward two-piece system, where the camera was connected to a 10 pound video recorder by a thick, black cable. He called it state-of-the-art and thought it's $2500.00 price tag was quite reasonable.

A few short years of high tech changes have turned that albatross into a single piece, palm-sized, electronic marvel that produces video approaching broadcast quality and sound that will knock your socks off. No one would have ever guessed that camcorders would so quickly replace still cameras as the favorite way to record those precious moments in our lives, the times we want to remember forever.

Since that afternoon pool party, home video has grown dramatically and will continue to be more widely used and enjoyed. The last time I walked through Disney World, I couldn't believe how many people were using camcorders to shoot their vacation fun. At the evening Light Parade there must have been 10 camcorders within arms length of my wife and I. You can bet that every one of those home videomakers, their family, and their friends, re-lived those good times over and over again.

We All Have a Story to Tell

There isn't much difference between the video I shoot with my TV news camera and what you'll shoot with your camcorder.

I tell a story with my camera, whether it be a fire, a political rally, or a football game. The pictures and sound are edited and the narration is added before it's seen in hundreds of thousands of homes during the evening news.

You'll use your camcorder to tell a story, too. Only your story will be about a vacation to Disney World, a weekend at the lake, or your child's birthday party. Instead of being seen by thousands, it'll be enjoyed by yourself, your family, and friends.

The Importance of Simplicity

The techniques I use at work must be simple. I don't have time for complicated and fancy production methods when I'm on a breaking story or when a deadline is hanging over my head. The viewer must be able to see as clearly as possible what took place without a lot of visual gimmicks getting in the way, gimmicks like excessive and unnecessary camera movement.

Fancy production methods and visual gimmicks will not only confuse your viewers, but could prevent you from getting the shots that really count. So keep it simple.

Edit in the Camera

If you're like most home videomakers, you won't want to take the time to edit your videos, so, what you shoot is what you'll see on TV over and over again, mistakes and all. Unless you plan to edit, you get one chance, and only one, to make each scene the best you possibly can and one chance to put the scenes in the order you want them. That's called "editing in the camera." The more you work at it, the better you'll get.

To tell your story you should use the same techniques I use to shoot television news. I know my techniques work because I use them when I make home videos of my family's vacations, birthday parties, and picnics. I also have taught these techniques to others in seminars, workshops, and classes.

Get the Right Equipment

If you're about to buy your first cam-corder or are considering updating with a new or more sophisticated one, read the next few paragraphs carefully.

Shopping for a camcorder can be a difficult and discouraging job. There are so many makes and models on the market that it's not easy to select the right one. If you're reading this book to find out what camcorder I would recom-mend, I'm sorry to disappoint you. I won't suggest specific makes and models for several very good reasons:

- There's a big price difference depending on the features on a specific camcorder and I don't know how much you are willing or able to spend.

- You may want a certain videotape format so your new camcorder will be the same format as your VCR or your family's VCR.

- You may not find a camcorder I suggest to be comfortable and easy for you to use. The variety on the market gives you a choice.

- New developments are coming onto the market so fast that any specific suggestion of mine could be outdated before you get to the store.

Don't Put Off Your Purchase

Don't put off buying a camcorder because you're afraid there's a big techni-cal advancement just around the corner that will make your investment obsolete. If you wait, just think of all those price-less memories you'll miss capturing on videotape.

It's true that new models offer new advancements in technology, but the basic technology will be around for a long time to come. If you take good care of your camcorder, it'll make just as good recordings five years from now as it does today.

Do Your Homework Before You Buy

There's more to picking a camcorder than you think. It's like buying a car: you're shopping for an expensive item and there's a large selection to pick from.

Before you buy a camcorder, do some research. You can start by reading camcorder and video magazines which offer detailed reviews of new models and charts that compare the features on a group of camcorders. Some periodi-cals publish annual directories that not only detail all the current camcorder models but accessories as well. Ask your friends what they like or dislike about their camcorders and whether they would recommend their camcorder

retailer. Make a checklist of those features you want and the models that match and decide on the price range that fits your budget.

Finally, visit a reputable dealer to look at the models on your checklist. You may need to visit two or three retailers because not all dealers carry all makes, and all models of each make.

Don't let some silver-tongued salesman sell you a camcorder that is already outdated and will be replaced by a new model as soon as you leave the store. The price discount is seldom worth it.

If you're confused by all the buttons and knobs that the manufacturers put on camcorders today, a simple point-and-

shoot camcorder may be for you. As the name implies, you simply set all the adjustments on automatic, frame up your shot, and shoot. Not only are point-and-shoot camcorders easy to use, but they're relatively inexpensive which means you won't spend a lot of money on special features you'll never use.

Be careful. Don't buy a simple camcorder if you think you'll soon outgrow it. That would be a costly mistake because the value of a camcorder on the secondary market is very small.

LUX Ratings

Most people want a camcorder that will produce good video in low light and modern technology has made it possible to shoot in remarkably low light. A camcorder's low light capability is measured in LUX. But, I wouldn't buy a camcorder based on the LUX rating alone. In fact, LUX would probably be the last consideration since most of today's camcorders have a LUX rating under 10.

To give you an idea of how much light that is, a little over 10 LUX is equal to one foot-candle, or the amount of light from one candle falling on an object one foot away. So you see that a difference of one or two LUX isn't enough to worry about.

Another caveat is that one manufacturer's rating of 10 LUX isn't equal to another manufacturer's rating of 10 LUX. This means that two seemingly equal camcorders really aren't equal.

Some camcorders have a switch that will boost the sensitivity under low light. These switches work by electronic amplification of the visual image, creating a major loss of video quality.

I'll talk more about LUX and how to use supplemental lighting to get sharper and more colorful video in Chapter Nine.

Autofocus

Although autofocus, a standard feature on virtually all camcorders, is highly touted by the manufacturers, it will not perform the trouble-free wonders most sales pitches claim. They are working on more sophisticated systems, but it's doubtful that all the problems will ever be completely overcome. I'll explain why autofocus is not reliable and how to work around it in Chapter Four.

Automatic White Balance

Automatic white balance is the one standard feature on a camcorder that works without fail. It continually sets the electronics for perfect color in virtually any lighting situation.

If you want to override the automatic white balance control, your camcorder's instruction book will guide you.

Automatic Iris Control

All camcorders have an automatic exposure control that sets the lens electronically. Only a few higher-priced,

more advanced or "pro-sumer" camcorders have lenses that let you manually adjust the iris. Limited adjustments in the exposure can be made electronically on your camcorder with an adjustable override. A slight increase in the exposure can be made with what has been mistakenly dubbed a backlight control. This feature doesn't control the light falling on the back of your subject, but simply tries to correct a false reading by the automatic exposure control.

Zoom Lenses

A zoom lens allows you to change the focal length of the lens. This lets you go from a wide-angle shot to a telephoto shot by pressing a button or rocker switch.

Most camcorders offer a 6-to-1 or an 8-to-1 zoom lens while some have 12-to-1 zooms. Anything longer is accomplished by an electronic system and results in a loss of picture quality. Anything over 8-to-1 will be difficult to hold steady at full telephoto without a tripod anyway.

Most zoom lenses have a macro setting that lets you fill the frame with an object as small as a postage stamp. Older camcorders have a lever to change from normal use to macro closeups, a lever that also focuses the lens. This awkward mechanical system may allow you to shoot extreme closeups, but it disables the zoom feature. Newer camcorders switch automatically into macro, and even let you zoom while in the macro position. And on occasions, the autofocus system in macro will function with some degree of reliability as long as camera movement is held to a minimum.

Other Features

Digital Image Stabilization is one of the newest and most welcome features. It takes the shakes out of hand-held video. I like it so much that I would not buy a camcorder without it.

Optional Editing. You may want a camcorder that can be connected to an editing system. A variety of systems are available and your salesman should be able to explain the difference.

Stereo Sound. Some camcorders have stereo sound systems. Stereo on a camcorder isn't at the top of my list. I find it to be a problem when recording conversation. It'll perform well when recording sound to the right or left of the mike, but sound straight ahead will be a little muffled.

LCD Screens. The newest viewfinder on the market is a small LCD screen. It's a camcorder and a small TV set all in one. The biggest advantage of the LCD viewfinder is its versatility. The camcorder can be held high over your head or placed on the ground without going through a lot of physical gyrations. You can use both eyes to view the color image instead of squinting at a tiny black-and-white image in a conventional viewfinder.

Another big plus is the ability to play back the video in color with sound without connecting it to a TV.

A variety of digital effects are also available depending on the make and model. But, I must caution you that you'll seldom use them unless you are planning to do some well-planned productions.

Try on That Camcorder Before You Buy It

There's only one way to tell if a particular camcorder is meant for you, and that's to put it in your hands and up to your eye. If the retailer won't take camcorders off the security mounts and let you get the feel of it, go to another retailer.

As you look at each camcorder, ask yourself these questions:

Is this camcorder comfortable to hold? Put your hand through the strap and around the grip. You should be able to comfortably put your thumb on the pause button and fingers on the zoom rocker.

Is the camcorder too heavy or too light? A big and bulky camcorder can be too much for an all-day sightseeing trip; too light a camcorder may be difficult to hold steady.

Can you hand-hold the camcorder steady? Put it up to your eye and see if it feels natural. Your left hand should easily support the camcorder.

Can you see clearly through the viewfinder? The viewfinder is the key to making good home videos. You can adjust the eyepiece to clear up the picture and make it sharp when the camcorder is in sharp focus.

Can the viewfinder position easily be changed to accommodate your needs? If you prefer using your left eye, be sure the camcorder has this option.

Accessories That Make Life Easier

There are five accessory items I consider necessities. I think they are so important I would recommend them

when you buy your camcorder. There are a lot of other things you can buy but resist the urge until you find them absolutely necessary.

Carrying Case — Your camcorder is a delicate instrument that needs protection when not in use. A carrying case will protect your camcorder from the hard knocks of travel, dirt and dust during storage, and provide a convenient storage place for your accessories. I prefer a hard-sided case, but soft cases are available if you prefer.

Tripod — A tripod will help you make steady pictures. Don't think the tripod for your 35mm camera will work because it won't have the stability or smoothness required for a camcorder. Buy a tripod that will support the weight of your camcorder. A wobbly tripod is worse than no tripod at all, and a tripod that doesn't pan or tilt smoothly is of no value.

An alternative for a tripod is a monopod. In many situations a monopod offers the steadiness of a tripod and the convenience of a hand-held camcorder.

Lights — As I said earlier, you can shoot in remarkably low light levels with newer camcorders. However, you will need to add some light in many situations to get the best color quality and image sharpness. There are several kinds of movie lights on the market that mount on the accessory shoe. I prefer battery-operated lights because I can use them anywhere without plugging them into a light plug.

You can make your own plug-in movie lights by using photoflood bulbs in aluminum-reflector work lights. The alligator clamps let you fasten the lights to a book shelf or top of a door.

Spare Batteries — There is nothing more frustrating than running out of power before running out of things to shoot. Always carry a fully-charged spare battery with you. Two spare batteries will get you through almost any day.

Videotape — Always keep a spare videotape cassette handy. Tape has an uncanny knack of running out just before baby takes those first few steps. Videotape cassettes have also been known to develop mechanical problems. I recommend you buy the highest quality videotape that's available to assure the best possible picture and sound quality, and for the highest mechanical reliability.

Chapter Two

The Key to Your Success

In the first edition of this book I waited until Chapter Eight to explain what I consider the single most important key to shooting enjoyable video. Not this time!

You must always remember this one simple little rule:

YOUR CAMCORDER WAS MADE TO RECORD MOTION — NOT CREATE IT!

Now, I would like you to pause a moment to commit that thought to memory and to reflect on what you think it means.

Putting it another way, you don't have to move a movie camera to make moving pictures. How important is this one suggestion? If I could gather all the home videomakers in the world together, I would make one suggestion. I would shout, "Hold your camcorder still! Don't pan! Don't zoom! Let the action that takes place in front of your lens provide the movement in your video."

Avoid the Garden-Hose Technique

Ever since we took our first snapshot, we've been told to hold the camera still, so it stands to reason that since your camcorder is a motion picture camera you should move it around to generate motion or movement.

In fact, you have an insatiable desire as a novice videomaker to keep that camcorder moving all the time you're shooting. As soon as you put the viewfinder up to your eye you start moving the camera, and you don't stop until you pause the tape and take the viewfinder away from your eye.

I call this undesirable technique "the garden hose technique." First you'll pan left, then you'll pan right, then you'll tilt the camcorder up and then back down. Next, you'll zoom in and zoom out. The camcorder is in constant motion during the entire shot, a shot that could last as long as a minute or more.

When you look at the results, you wonder what's wrong with your video and why it doesn't look as good as your favorite TV show. The video gives you a feeling similar to watching a tennis match from a roller coaster. Don't wave the camcorder around indiscriminately as you would a garden hose while watering the tomatoes.

Most of the video you'll shoot will have plenty of motion in it. But, even if there is no motion in the shot, don't feel obligated to create it by moving the camcorder. If it's an interesting picture, it'll

hold the viewer's attention without camera movement.

Constant camera movement is a bad habit that must be broken if you want to shoot enjoyable home videos. I know it'll take concentration to break the habit, but the effort will be well worth your time.

An Old Rule: Hold the Camera Still

Take that old and tested rule used for taking snapshots and apply it to your videomaking, even though it's called a motion picture camera. Let the objects provide the motion.

Try This Hands-On Learning Experiment

Take your camcorder outside and make a five to eight second pan of the homes in your block. Then, make several six-second shots holding the camcorder still and steady, moving to the various positions that will give you the best picture.

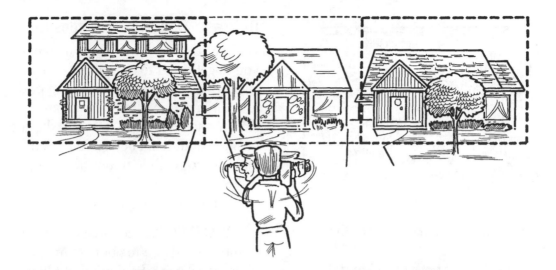

Go to the end of the block and shoot a wide shot of the neighborhood.

Then make a shot of the kids playing ball.

Next, make a shot of the house across the street.

Now make a shot of the guy next door mowing the lawn.

And, finally, make a shot of the family dog.

Now, look at both videos and decide which looks best. I'll bet there's no comparison. The version with the shots where the camcorder is held still and steady wins hands down.

Panning and Zooming

Before I move to some basic rules, let me briefly define the terms "panning" and "zooming." "Panning" is movement of the camcorder from right to left or left to right to show a panorama rather than the limited area the lens can see if the camcorder were held still and steady. "Zooming" is changing the area the lens sees by increasing or decreasing the focal length of the lens.

Rule #1: Don't Pan Unnecessarily

I was tempted to leave the word "unnecessarily" out of the title feeling that it would be better never to pan at all. But, there are times when a pan, if done correctly, can enhance your videos. I just want you to keep from panning constantly and without reason.

Rule #2: Don't Zoom Excessively

The zoom lens was made to allow you to get closer to or farther from your subject without actually changing positions. In most situations, the zoom feature should be used to set up the composition of the shot before you roll the tape, not to zoom in or out from your subject while the tape is rolling. But again, there are exceptions.

REMEMBER: A zoom lens is not a trombone and you're not marching in the high school band. So don't use it like a trombone. There's an added incentive not to overuse the zoom lens: A power zoom uses battery power and every zoom eats up power that could be used to make pictures.

Rule #3: Know the Exceptions to Rules #1 and #2

As you're well aware by now, I make it a rule not to pan or zoom. However, there are times when even the best of rules can, or even should, be broken. To break a rule, you should have a good reason and should know how to do it. Here are some examples:

You can pan if you can't get back far enough to get everything in one shot.

For example, the Grand Canyon is too big to produce meaningful video in one shot. The dotted-lined frame in the following illustration indicates how little of the scene you can see in a shot where the camcorder is held still and steady. Panning will help to show how big this Wonder of the World really is.

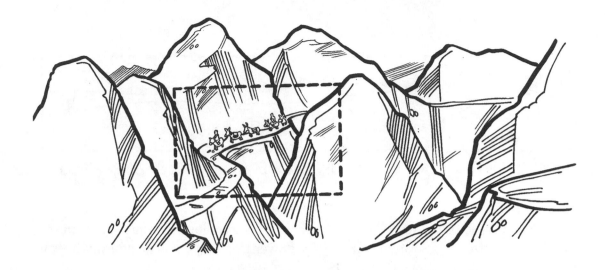

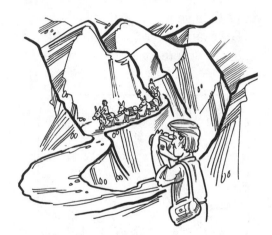

You can pan to create atmosphere. For example, you can pan slowly across the crowd at a football game to emphasize the size of the crowd.

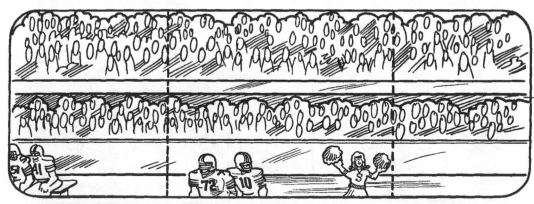

START HERE → PAN SLOWLY → STOP HERE

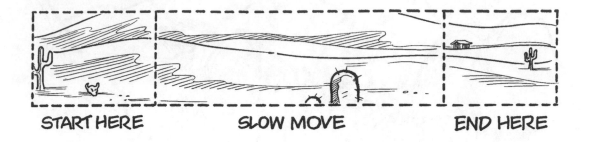

START HERE **SLOW MOVE** **END HERE**

You can pan across a desert landscape to dramatize its desolation and spaciousness.

A zoom can be used creatively to emphasize a subject.

For example, you can shoot a wide shot of a desert scene ...

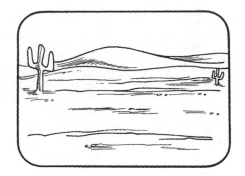

...and then zoom in on a single, solitary flower.

This technique not only shows the flower in detail, but also indicates its solitary location.

Sometimes it's effective to zoom out from a tight shot to reveal the whole scene.

For example, you can start with a tight shot of someone dozing in the shade...

... and then zoom out to show the activity around him.

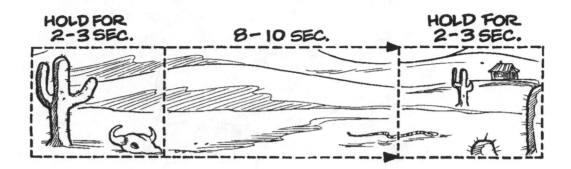

How to Pan Correctly

A pan of the landscape should be as smooth as glass—slow and deliberate—to avoid a blurry, jerky picture.

If you're shooting wide open space such as a desert scene and you want to show spaciousness and desolation, try this method:

1. Study the scene to see where you want to start panning and where you want to end up.

2. Through the viewfinder, frame a well-composed picture.

3. Roll the tape, holding the beginning of the shot still and steady for two or three seconds.

4. Begin your move, making a slow and steady sweep from left to right across the desert. Depending on the scene, the move may take as much as eight to ten seconds, maybe longer.

5. At the end of the pan, hold the shot still and steady for two or three seconds before pausing the tape.

Your shot will show the vastness of the desert and you'll have a shot that can be easily understood by your viewers.

CAUTION: Don't pan on the next shot. Pick something interesting in that scene and make a still and steady shot like a close-up of a pretty little desert flower or a prickly cactus.

Practice Before Rolling the Tape

To make sure your video will look the way you want it to, try a "dry run" before rolling the tape. If it doesn't look good to you through the viewfinder, try it again until it does. A little practice will help you get just the shot you want.

Following Action is Not Panning

Moving the camera to follow a moving object requires movement similar to panning. However, following a moving subject is not the same as panning. That's because the object of interest stays in the frame throughout the shot.

If you're taping the kids running across the beach and diving into the water, the background may be a blur but your subject remains reasonably sharp as you keep it in the frame. If you analyze your video, you'll find yourself following action a fair amount of the time.

How to Zoom Correctly

The technique to use when zooming is quite similar to the technique used when panning. To explain, I'll use the same desert scene:

1. Find a pretty little cactus flower.

2. Frame a wide shot in the viewfinder.

3. Roll the tape and hold the shot still and steady for two or three seconds before starting to zoom into a close-up of the little flower.

When you reach the end of the zoom, hold the close-up shot for two or three seconds before pausing the tape.

Your shot will take your viewers from the vast wasteland and focus your attention on the flower, dramatizing the delicate life and beauty of the flower in an apparently hostile environment.

CAUTION: Don't zoom during the next shot and don't pan. Pick another subject of interest, perhaps another close-up view of a flower.

REMEMBER: The key to better home videos is: "Record motion — Don't create it!" A shot that is still and steady is a lot easier to understand and enjoy than a shot that consists of constant camera movement. You, your family, and friends will enjoy your videos much more if you let the action in front of the lens provide the motion in your video.

Chapter Three

Avoid the Shakes — Make Steady Pictures

Let's face it, shaky pictures are no fun to watch and a tripod will hold your camcorder rock-solid, giving you steady pictures. If I were to give you a list of accessories that I think all videomakers should have, a tripod would be near the top of the list.

However, while I think you should own a tripod and know how to use it, there are some things you just can't shoot when your camcorder is locked down on a tripod. You need to know when to cast aside that tripod and "shoot from the shoulder."

Learn to Shoot without a Tripod

I keep a tripod handy at all times, no matter whether I'm shooting news or making home videos. However, often times a tripod is more trouble than it's worth so I choose the freedom of a hand-held camcorder, even if I'm not guaranteed perfectly steady video. And I'm sure you'll find that a tripod makes it impossible to get video you really want.

I remember a few years ago watching a man at a celebrity golf outing trying to move around with his video camera, separate recorder, and tripod. He was trying to shoot video of his favorite sports personalities who were scattered all over the course. I first spotted him at the edge of the practice green shooting some celebrities clowning around before they teed off. This was fine. It gave him a steady picture even when he zoomed in for a close-up.

Then, he picked up everything and raced over to the 1st tee for some more shots. Next, he rushed off to the 9th green, and from there over to the 10th tee. After that, he went back to the 1st tee and, finally over to the 18th green. Each time he moved, he had to set down the recorder and adjust the tripod legs to level the camera and square up the picture. In this case the tripod became a three-legged monster.

The video he managed to shoot was steady as a rock, but, he missed most of the shots he wanted. By the time he was ready to shoot, the celebrities were gone. I know he must have been exhausted by the end of the day.

If you're on vacation, the last thing you'll want to do is carry a camcorder and a tripod around all day long. The load will be awkward and will get heavier as the day wears on. If you have a memory like mine, you're likely to set the tripod down somewhere and walk away without it.

So, cast off your crutches and learn how to handhold your camcorder as steadily as possible. This ability will let you move quickly and easily from one shot to another as the action moves from one place to another. When you get the knack of holding your camcorder steady without a tripod, you'll get the pictures other people miss.

Electronic Image Stabilization

One of the best features offered on some camcorders is "electronic image stabilization" or EIS. This innovation isn't for every situation and won't eliminate the occasional demand for a tripod, but EIS will help you shoot steadier video in most situations without using a tripod.

EIS works exceptionally well, eliminating virtually all of the camera movement when you hold the camcorder still and steady, and most of the movement in your telephoto shots. However, you will encounter some problems when you pan with EIS.

EIS looks at any movement of the camcorder as unwanted movement. So the beginning of a pan will have a slight but noticeable lag, then the picture will jump a little to catch up with the lens. At the end of the pan the picture will try to keep moving before settling down on the scene in front of the lens. You may also notice a slight strobe effect in a scene where the action is erratic.

To eliminate any unwanted affects of EIS, just turn it off for a shot.

Take Steady Handheld Video

For most of your handheld video you'll simply put the viewfinder to your eye and roll the tape. In most situations, you'll find it easy to shoot relatively steady video by following a few simple suggestions.

Think of yourself as a human tripod. Face your subject and spread your feet apart so they are directly below your shoulders. Bend your knees slightly. Grasp the handle of the camcorder with your right hand, using a firm but light grip, the same as you would hold a golf club. Use the thumb of your left hand to help steady the camcorder by supporting the lens or body of the camcorder. The fingers of your left hand will now be in a position to operate the controls on the side of the camcorder. Tuck your elbows into the sides of your body.

Next, take a deep breath and relax. Gently squeeze the pause button to roll the tape. Exhale slowly and steadily as you record the shot. Squeeze the pause button again to pause the tape.

At first, this procedure may seem a little awkward. However, it works, so keep trying. With a little practice you'll be able to hold your camcorder quite steady for as long as it takes to record most shots.

There will be times when you simply can't hold your camcorder steady, no matter how hard you try. For example, it's hard to hold a camcorder still and steady on a windy day. Also, the more you extend the zoom lens into the tele-photo position, the shakier your pictures will be. When I have difficulty holding my camcorder steady, I improvise. Here are three ways to shoot steady video without a tripod:

Lean Against Something

When I can't hold my camcorder steady I look for a tree, a utility pole, the side of a building or anything else I can find to lean against for extra support. You'll be amazed at how much it helps. By leaning your shoulder against some-thing, you'll still be able to move your hands and the camcorder slightly to make needed framing adjustments. You'll even be able to zoom and pan slightly and still hold the camcorder steady.

Rest Your Elbows

In some situations, I'll look for something to rest my elbows on, such as the hood of a car, a picnic table, or a fence. My arms help form a human brace that is almost as steady as a tripod. If you're sitting in a chair, rest your elbows on the arms of the chair to steady the camcorder.

Use a Flat Surface

Sometimes I'll set the camcorder on a flat surface like a table, a rock, or a fence post. Nothing can hold the camcorder any steadier, not even a tripod. When you use this method, you may have to make slight adjustments in the tilt of the camcorder to get the framing you want. To make these slight adjustments, slip a coin, a book of matches, or a twig under either the front or back of the camcorder.

Using a Tripod

If you intend to shoot with your camcorder for long periods of time from one location, by all means, use a tripod. When you're shooting a sporting event from a fixed location, recording a play or speech, or using the zoom lens in the full telephoto position to shoot anything at a distance, you'll want to use a tripod.

Since tripods aren't the easiest things to work with, here are a few helpful tips:

Work at a Comfortable Height

Set the tripod so the camcorder is at a height that lets you stand comfortably. Place your right hand on the tripod handle, your left hand on the camcorder controls and your eye at the viewfinder. Don't try to put your right hand through the handle strap and around the grip. If you do, you'll feel like a human pretzel.

Position and Tighten Tripod Legs Securely

To protect your expensive camcorder from falling, be sure the sections of the extended tripod legs are clamped tightly and the legs are spread evenly. Also make sure the camera is securely attached to the tripod, especially if your tripod has a quick release.

Don't Leave Camcorder Unattended

Don't leave your camcorder and tripod unattended in a crowd. Someone is sure to trip over the tripod leg, breaking your camcorder and perhaps their leg, too.

Monopods

If you don't want to struggle with a tripod, but need something to help eliminate the shakiness in your video, try a monopod. A monopod is a one legged device which can steady your camcorder and still give you a certain amount of mobility. It's like resting your camcorder on a fence post, only you can move the post from place to place. To see the effectiveness of a monopod and access the value of owning one, try turning your tripod into a monopod. Extend one leg to place the camcorder at eye-level and leave the legs folded together. If you think this might work for you, you may want to add a light-weight, collapsible monopod to your collection of accessories.

Chapter Four

Focusing Your Camcorder

You have to focus your camcorder before you shoot a scene to make sharp, clear videos. Sound elementary? Of Course! But the fact is that some people get so involved in what they're shooting they forget to focus, and the result is fuzzy pictures.

Focus Before Each Shot

Focusing your camcorder is simple. You can either depend on the camcorder's autofocus system or focus manually by rotating the focus ring, located on the front of the lens, until the image in the viewfinder is as sharp as you can get it.

I instinctively focus manually before every shot I make and you should make it a habit, too. The reasons why I suggest focusing manually will become clear as you read the rest of this chapter.

What is Focus?

Before I go any further, I should explain focus and why it is so important in shooting better home videos.

The word "focus" means, among other things, to concentrate. You may not have thought much about it, but as you concentrate on an object your eyes focus on that object leaving everything else blurry or "out-of-focus." You don't have to worry about focusing your eyes because your brain does it for you, automatically. If you look at something up close and then at something far away, your eyes will quickly change focus from close to far almost without you noticing it.

As a graduate of the snapshot school of still photography, you never had to worry about focusing your camera either. Everything was in focus because the camera used a wide-angle lens. However, your camcorder has a complex zoom lens that extends from wide-angle to tele-

photo, making the function of focusing the lens very critical.

Depth of Field

Depth-of-field (or "depth-of-focus") refers to the portion of a picture that appears sharp. All other objects in the picture, either in front of or behind the depth-of-focus range, will be blurry or out-of-focus. Depth-of-focus varies with three conditions:

- The camera-to-subject distance, or the distance between the camera and your subject.

- The lens opening or aperture, which is dependent on the amount of light on the subject.

- The focal length of the lens or the focal length of a particular zoom lens setting.

Now, let me put all these complicated-sounding conditions into a couple of simple situations:

You'll get the most depth-of-focus when the lens is focused on a subject about 10 to 15 feet from the camcorder, when the lens opening is small because you're shooting in bright daylight, and when the zoom lens is set at its shortest focal length or its maximum wide-angle setting. In these conditions you can't miss getting sharp video. By setting the focus ring of the lens at 10 to 15 feet, everything will be in focus from a couple of feet in front of the camcorder to infinity.

A wide shot in daylight 10-15 feet from the camcorder maximizes depth-of-focus.

A telephoto shot taken close-up yields shortened depth-of-focus.

You'll get the least depth-of-field when the subject is as close to the camera lens as the lens will focus, the zoom lens is at full telephoto, and the light on the subject is at a minimum. Under these conditions, the depth of focus may be no more than an inch or two.

Pick an object 12 feet away from your camcorder, like the bear in the illustration below, and set the focus ring at 12 feet and the zoom lens at its widest setting.

The bear at 12 feet away from the lens will be in sharp focus. Because this is a wide-angle shot, the bird in the foreground (6 feet from the camcorder) and the bear in the background (20 feet away) will also appear to be in focus.

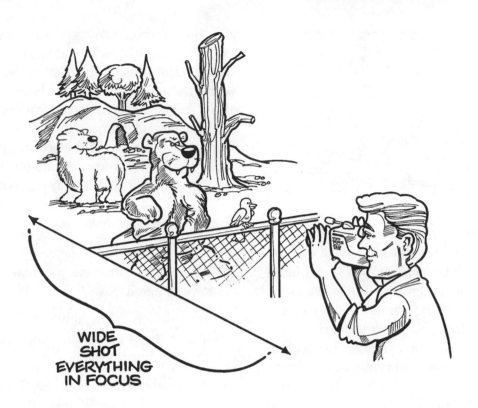

WIDE
SHOT
EVERYTHING
IN FOCUS

If you zoom in on the bear, the depth-of-field will be reduced and you'll have a sharp bear but the background and foreground will be out of focus.

To see how critical sharp focus can be, try this comparison with your camcorder:

Aim at an object, in my example, the bear, 12 feet away but set the lens to focus at 6 feet. With the zoom lens in the wide-angle position both the bear and the bird and even the background look sharp. That's because the wide-angle lens setting gives the greatest depth-of-focus.

Now, without moving anything, zoom in tight on the bear in the middle. Now, both bears are out-of-focus but the bird in the foreground is in focus.

With this experiment you have discovered that you don't have to be pinpoint accurate when you're shooting wide-angle shots in bright daylight but you must be pinpoint accurate with tele-photo shots in dim light.

To be sure you have a sharp, clear picture every time I recommend you focus your camcorder, as I do, before every shot.

The Problems with Autofocus

After all this, you may ask, "Why should I worry about focusing when I have autofocus?" Just because the salesman said autofocus is great, don't assume that autofocus will do the job.

When autofocus was first introduced, it was generally felt that it was the answer to all possible focusing problems, but it hasn't worked out that way. More times than not, autofocus will cause you problems, sometimes where you might least expect them. Your camcorder owner's manual will list the situations that create problems for your particular camcorder and its autofocus system.

How Autofocus Works — Autofocus works a little like radar and sonar. A small transmitter on the front of the camcorder sends out an invisible beam of light that strikes an object in front of the camcorder and bounces back to hit a sensor near the lens. The electronic circuits inside the camcorder convert the length of time it takes that beam to make the round trip and sets the lens for the camera-to-subject distance.

The Problems with Autofocus — Here are some of the situations that make your autofocus unreliable.

- Dark objects in low light will absorb the beam making automatic focusing impossible.

- A smooth and shiny surface, if not shot straight on, will reflect the beam as a mirror reflects an image.

- Autofocus will have difficulty focusing on very small objects, or subjects that are not in the center of the frame.

The manufacturers have tried all kinds of things to make autofocus 100 percent reliable. No matter how hard they try, they can't seem to develop an autofocus system that can evaluate situations as the human brain does.

Generally, the autofocus system will key on whatever is in the center of the viewfinder and closest to the camcorder. Because your camcorder can't think, it doesn't know what you're planning to shoot and it may not focus on your subject. In the following illustration, the subject is the penguins.

Say you were trying to shoot the whole scene above, capturing all of the penguins in a still shot.

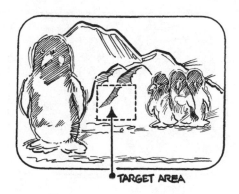

TARGET AREA

The autofocus beam will dutifully do its job. It will go right by the penguin on the left and the group of penguins on the right and hit the iceberg wall in the background. The background will turn out sharp, but the penguins on the right, the primary subjects, will be out-of-focus. The penguin on the left will be even more out-of-focus.

An obstacle between you and your subject can produce similar poor results. For example, if there's a fence between you and your subjects, the autofocus system will focus on the fence because it is the nearest object.

This leaves your subjects, in this case, the monkeys, out-of-focus.

If someone walks between your camcorder and the subject, the autofocus will go wild. It'll suddenly and momentarily measure the distance to that person and shift the focus before resetting itself to the monkeys. This shifting of focus makes your video hard to watch.

2. Zoom in tight on your subject with the zoom lens to fill the viewfinder frame with your subject.

If your subject is only a small part of the overall picture, the slightest bit of movement of a hand-held camcorder can throw the autofocus off its intended target. As a result, your picture will go in and out of focus, creating more bad video, as the autofocus system tries to do its job. This searching for focus is particularly objectionable when the depth-of-focus is very limited.

Using Autofocus

The best way to use autofocus is to let it work for you. Here's how to use autofocus to your advantage:

1. Leave the camcorder's autofocus switch in the "manual focus" position.

3. Then push the "push-to-focus" button (or similar control) to make a one-time autofocus setting. Hold it in or down until the picture in the viewfinder is sharp and then release the button.

4. Now re-set the zoom lens to the shot you want and roll the tape to shoot the video.

By using this method of focusing, every shot you shoot will be in sharp focus and it will be almost as quick and easy as using full-time autofocus.

The Advantages of Focusing Manually

Manually focusing your camcorder lens takes a little extra time but is well worth the effort as you'll get sharp video every time. Of course, if you're working in conditions where the autofocus system isn't reliable, as explained earlier, you'll be limited to the old-fashioned way of focusing...focusing manually, anyway.

To focus your camcorder manually, zoom in on the subject you're going to shoot until you fill the frame with a small portion of your subject.

Then rotate the focus ring on the front of the lens back and forth until the picture in the viewfinder is as sharp and clear as you can make it. If I'm shooting a person, I like to focus using the glint of light on a person's glasses, the lines in the lips, or the eyelashes. These lines are more defined and are easier to see in the viewfinder.

When you have found the sharpest focus, re-set the zoom lens to the desired framing and push the button to roll the tape and make the shot.

Focusing Unconventional Camcorders

You may have a camcorder that does not have a focus ring on the front of the lens. If so, you may have to resort to an unconventional method to manually focus your camcorder. Consult your owner's manual for detailed instructions and then practice the manufacturer's recommended method.

Always Be Ready to Shoot

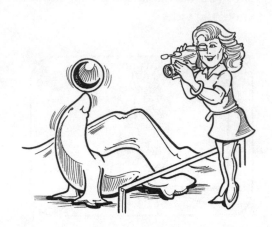

I make it a habit to be ready to shoot at all times. There will be occasions when you'll see a shot you want and you won't have time to focus. You're most likely to get a good, sharp image in most situations when your camcorder lens is set at 15 feet and the zoom lens is at its widest setting. While the tape is rolling, make any minor adjustments that are necessary to sharpen the picture as you're shooting.

Chapter Five

The Viewfinder — What You Shoot is What You Get

Shooting video is a lot different from taking snapshots. With snapshots, you can go through a freshly processed stack of prints and throw away the bad ones before anyone else has a chance to see them. The mistakes might include pictures that are out of focus, misframed shots which have people's heads cut off, and shots which show buildings leaning like the Tower of Pisa. Even when you shot the old-fashioned 8mm movie film, you could cut out the parts you were not proud of and splice together a neatly-edited version of your vacation.

With videotape, what you shoot is what you'll see when you play it back on TV, unless you edit the tape—which isn't easy. The easiest way to improve your video is learning to see what is in the viewfinder and making the necessary corrections to make it right before you roll the tape.

Now, don't get the impression that soon after you read this book that you'll be able to shoot a vacation video without mistakes and other unwanted scenes. I've earned a living with a video camera for decades, and even I can't make every shot perfect. However, your home videos will improve greatly if you follow some simple suggestions.

If you get the impression from the following suggestions that I'm a little fussy, you're right. As a television news cameraman, I get paid to be fussy about good video. As you learn right from wrong, you'll probably become more fussy, too. However, if you never take the time to learn right from wrong, you won't know what to look for in the viewfinder.

What a Difference Good Framing Makes

Your camcorder's viewfinder is like the frame around a picture on the wall. A badly framed and poorly matted picture detracts from the art it contains. A picture hanging crooked sticks out like a sore thumb and your first reaction is to reach out and straighten it. Your video will also look bad when you watch it if you don't take time to carefully "frame" each shot.

Since what you see in the viewfinder is what you'll see on your TV screen when you play it back, don't roll the tape until the picture is the way you want it. I can't emphasize this enough! By waiting to roll the tape until after you have correctly framed each shot you will eliminate a lot of the kind of unwanted camera movement I talked about in Chapter Two.

My Shooting Checklist

To make sure my video is the way I want it, I quickly go through a mental checklist as I frame each shot. Then, after I have corrected any problems, I push the button to roll the tape and make the shot. As the tape is rolling, I continue to check the picture in the viewfinder to make sure the video stays the way I want it.

Here's the checklist I run through before I roll the tape:

1. Is my horizon level?

2. Have I cut off my subject's head?

3. Do I have too much space above my subject?

4. Am I too close or too far from my subject?

5. Are there distractions in the background or foreground?

6. Do I really want this shot?

At first, it may not be very easy to properly frame your shots. After all, you're not used to looking through a viewfinder with one eye open and the other eye closed. Nor are you used to looking at the world on a tiny, two-dimensional, low quality, black-and-white TV screen which is what the viewfinder on most camcorders actually is. And it has to be difficult to relate what you see in the viewfinder to a frame since there is nothing but black surrounding the picture.

However, when you learn to recognize a poorly framed shot and learn what to do to correct your mistake, you'll be amazed at how much difference the little things make. With practice, going through the checklist will become virtually automatic and you'll have taken a giant step toward better home video movies.

1. Level Horizon

In some of the home videos my friends have shot I've seen buildings and trees that look like they are about to fall over and rivers that appear to be flowing uphill.

I even find myself shooting an occasional shot where the horizon is off kilter.

It's easy to square up your camcorder to make the horizon level and buildings stand upright. Pick any vertical line near the center the picture and line it up so it is parallel to the edge of the viewfinder frame.

Don't use horizontal lines to square up your picture. In most cases, the lines of perspective will cause you to tilt the camcorder, forcing the vertical lines to be off. Try it and see what I mean.

2 & 3. Enough Headroom

Don't cut off the tops of the heads of people in your videos and, at the other extreme...

... don't leave too much empty space at the top of the frame.

Frame the picture so your subjects look their best. Always be aware of the relationship of your subject to the bor-

ders of the viewfinder. Remember, the framing of the picture in the viewfinder determines the framing on the TV screen.

4. Too Close...Too Far

As you look at your subject think about what you want to show, then select the right viewpoint and the correct distance from the subject for the best picture.

If you're too close to your subject, or if your zoom lens is set at too long a focal length, you'll cut off part of your subject. Either back up or zoom out with your zoom lens until you have the picture in the viewfinder that you want to see on your TV.

If you're too far away from your subject, or your zoom lens is too wide, you'll miss some detail you really want to show. In this case, either move closer or zoom in with the lens for the best picture.

5. Avoid Distractions

Pay as much attention to the background as the subject itself. If the background doesn't look just right, make the necessary changes before rolling the tape.

Don't let plants, trees, or other objects "grow" out of your subject's head.

For example, if you see a large vase growing out of your subject's head, move to one side or the other so the vase sits on the shelf as it should.

Distractions aren't always static like a vase or a tree. Look for unwanted moving objects, such as cars, people, or animals moving through the background of your picture while you're shooting.

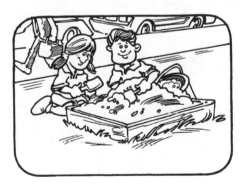

Other distractions might be a bright reflection from the sun off a car window or strong patterns like that of a brick wall.

You'll not only find distractions in the background but in the foreground as well. A fence or someone walking between you and your subject should be avoided.

The easy way to avoid or minimize background and foreground distractions is to move closer to the subject or by changing your shooting position or view-point.

By doing so you will avoid making your subject look silly or pulling the attention of the viewer away from your subject. In the long run, it's worth the time and effort.

You've seen television video where a crowd of people goes wild waving and making faces at the camera. As a TV news cameraman, I always try to avoid such obnoxious intrusions into my video and I recommend you do the same. I always try to avoid someone waving at the camera and shouting "Hi, Mom!" or "Hey, man! Take my picture!" Such uninvited performances make your best efforts look amateurish. There's nothing worse than having someone ruin a one-in-a-lifetime shot by being obnoxious.

6. Do I really Want This Shot?

Even after you've properly framed a shot, you don't have to roll the tape. Be selective in what you shoot. If you've already shot a certain scene, don't shoot it again. A little restraint will improve your home videos as much as anything.

Each of the points I've made in this chapter may seem minor to you. But, believe me, a lot of little things add up to make a big difference in your home videos. And that's especially true, of course, when your only chance to edit is in the camera as you shoot. Remember, five minutes of well-shot video is much more enjoyable, effective, and memorable than fifteen minutes of irrelevant and disjointed video.

Chapter Six

Anticipation and Timing — When to Roll Tape

Anticipation and good timing are keys to success in almost anything we do. It takes the ability to know what's going to happen and when it will happen to get above average earnings out of the stock market, to operate a successful business, and to make good pictures with a still camera. Your ability to anticipate along your sense of timing tells you when to snap the shutter and "freeze" the action at its peak.

With the still camera up to your eye, you wait for that precise moment, that fraction of a second you want to preserve on film, to be enjoyed over and over again for years to come. For example, a single picture, taken at the right moment, can capture a toddler taking his first steps. It was anticipation that told you to look through the viewfinder and timing that told you to snap the shutter.

Timing with Video

Making home videos requires anticipation and timing, too, but it's a lot different. Timing in shooting motion pictures is dependent even more on anticipation than taking snapshots. And to develop your sense of anticipation and timing, you may have to break some old habits and develop some new ones.

Instead of waiting for the peak of the action to snap the shutter, you must anticipate what's going to happen and roll the tape before the action begins. Then you must keep the tape rolling until that bit of action has ended.

Keep Your Viewer in Mind

You must always remember that your audience, your family, and friends who are going to look at your video, weren't standing beside you watching what happened as you shot an event. They don't have the advantage of knowing what took place before you rolled the tape and after you stopped it. They can't rely on their memory as you can to fill in the blanks left in poorly timed video.

To orient your viewers with any action scene my rule is to give them two or three seconds of video before the action starts and a couple of seconds after the action ends. A new scene that begins after the movement has started is confusing. A scene that ends before the action has ended leaves the viewer wondering what happened long into the next scene

Think Video for Better Timing

For a still photographer, anticipation and timing are the keys that unlock the magic of the moment.

You wait for the crucial moment and then snap the shutter. A fast shutter and a quick trigger finger can freeze the action in a fraction of a second. At a baseball game, for example, you can freeze the ball leaving the end of the bat, the power of the batter's muscles, and the deep concentration etched on the his or her face.

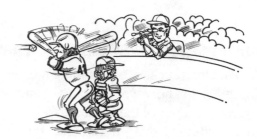

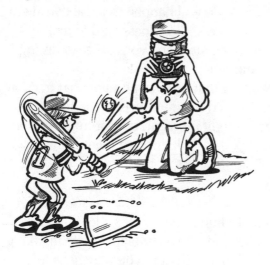

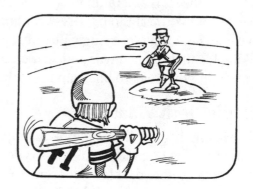

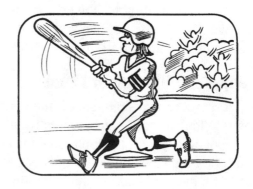

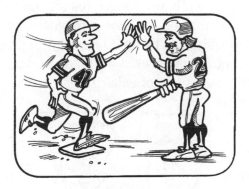

If you roll the videotape after the batter has started to swing the bat, you'll miss your shot. You may have seen the entire event take place but your viewers won't. You must roll the tape before the pitcher starts the windup and continue to roll as the batter hits the ball, rounds the bases, and crosses home plate to be congratulated by jubilant teammates.

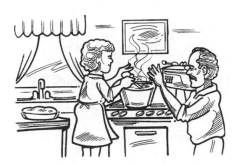

When mom takes the turkey out of the oven on Thanksgiving Day...

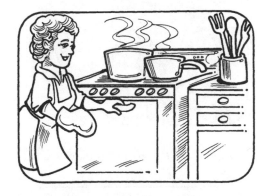

...roll the tape before she opens the oven door...

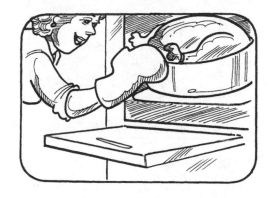

...and keep it rolling as she checks the bird...

...sets it on the top of the stove...

When Jimmy and Joshua are building a castle on the floor with blocks, you probably won't want to record the entire event. To get an exciting, but brief, yet complete piece of video, roll the tape...

...tests it and says that dinner is ready.

Be Selective

There will be times when you'll want to record continuous action and you won't be able to roll before the action begins and continue until the action is over. It would be too long a shot. So, you must learn to think of action in terms of bits and pieces.

When you learn to see the separate and distinct pieces of action that make up a long-running scene, you'll shoot better home video movies. With a little practice, you'll be able to pick the best times to roll and pause the tape without making your video too long and boring.

...just before Jimmy reaches for the final block...

...and keep it rolling as he puts it on top of the stack...

At the circus, roll the tape a couple of seconds before the clown begins to juggle the pins...

...and he and Joshua react to their success or failure.

You'll end up with eight to ten seconds of interesting video rather than two or three minutes of dull video.

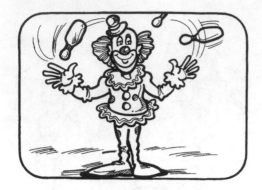

...and keep it rolling until after he reacts to dropping one of them.

Again, this will give you an interesting shot instead of a long, boring shot.

It may seem like a difficult ability to develop and a lot of work just to shoot home videos. But, when you add effective anticipation and timing to the many other skills you'll learn from reading this book, you'll enjoy cleaner, more interesting videos.

Chapter Seven

How Long and How Short to Make Each Shot

Using a camcorder to shoot videos may not be your first experience with a motion picture camera. You may be one of those pioneers who owned an 8mm movie camera. If you shot 8mm movies, you are well aware that film and processing cost a small fortune. The camera may have been relatively inexpensive, but it took a lot of money to keep it running.

If you weren't careful, taking movies of a two-week vacation could eat up the next two weeks grocery money. To keep peace and harmony in the family, you were just a wee bit conservative, and you shot only the most interesting moments of your trip.

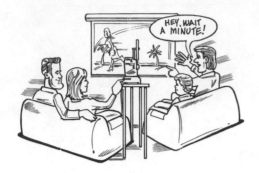

If you tried to squeeze an entire two-week vacation onto one or two rolls of film, you came home with shots that were so short in duration that the pictures shot out of the projector like bullets out of a machine gun. Before your family and friends had a chance to figure out what was in the first shot, four or five more had flashed by, leaving them to cry out, "Hey, wait a minute! What was that? Roll it back! I missed that!"

Another problem created by the high cost of film and processing was the inability to shoot enough film to gain experience. It simply cost too much to experiment with new and different ideas. So you were never able to improve your shooting ability. Movie cameras were generally used only on very special occasions. I have a friend who used his movie camera so little that he had three Christmas celebrations and two birthdays on one three-minute roll of film.

When you graduated from film to videotape, you discovered a new freedom. Videotape is inexpensive and there's no need for costly processing. With your camcorder you can shoot as much as two hours on a single cassette and you can look at the results almost immediately.

This newfound freedom comes with some real dangers. If you've just bought a new camcorder, you'll be tempted to shoot everything you see and your shots will be very long. As you and your viewers will find out, the results will be...B-O-R-I-N-G!!!

Shooting good home videos, no matter how inexpensive and convenient it may be, still takes thoughtfulness and selectivity.

Guidelines for the Length of the Shot

I can't give you a list of hard and fast rules on how long each scene should be or how much tape you should shoot during any given situation. You'll have to learn that through trial and error as you develop your videomaking ability.

However, I can offer you some general guidelines.

When you watch television, you need a certain amount of screen time to see and comprehend what is in a scene. Too little screen time creates confusion. You'll still be trying to figure out what you saw in one scene when you're confronted with the next scene. At the other end of the equation, too much screen time for a shot will make your video dull and boring.

When you are shooting video, think about the viewer in front of the TV set, a viewer who wasn't there to see the event in person. The length of each shot must be long enough to make it comprehensible but short enough to keep the show exciting and interesting.

Simple and Complex Scenes

The amount of screen time given to each shot will depend largely on the content of the picture.

Simple scenes don't require a long time on the screen for your audience to comprehend. Scenes with a lot of detail require a longer screen time.

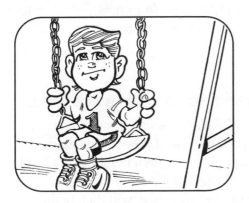

It may take only three or four seconds of screen time for your viewers to see and understand the picture of a child sitting on a swing.

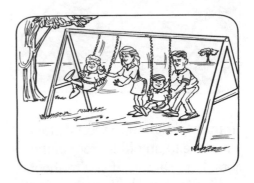

It will take as much as eight or ten seconds, even longer, for your viewers to comprehend everything in a shot of the entire family playing on a swing set.

Action Scenes

The amount of action in your video will also help you determine how long to make each shot.

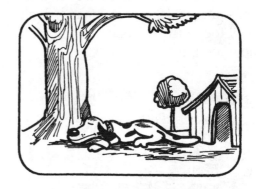

If your subject is moving, it will take longer to see the whole picture than if the subject is still. The shot of a sleeping dog, for example, may need only four or five seconds of screen time.

It may take 10 to 15 seconds for an action scene to unfold in front of the camera. For example, if you're shooting your dog chasing a ball, you'll want to let the tape roll until he's picked up the ball and brought it back.

Again, Be Selective

Not only should you think about the length of each shot, you should also think about the amount of videotape that you shoot during an event. I can't tell you how much to shoot but I can give you some guidelines. In general, don't shoot too much videotape and don't shoot too little.

At your family reunion, you may be tempted to shoot a half hour or more of grandma playing with the newest member of the family. That's way too much tape, unless you plan to edit your videotape.

Instead, pick and choose your shots. Record a couple of minutes of grandma and the baby and look for all the other interesting happenings at the reunion. If you shoot two hours of videotape, you may look at it once and throw it in a drawer with all the other two-hour tapes you've shot.

Don't shoot the entire baseball game, even if your youngster is playing in it. Instead, look for bits and pieces that will make interesting video when played back five years from now. Ten minutes of interesting highlights are much more enjoyable to watch than two hours of boring baseball.

The Exceptions to the Rules

Like all rules, you must know when to use them and when to break them. For example, your own personal interest in a particular subject, or that of your intended audience, will dictate the length

of your shots as well as the amount of video you'll shoot.

If you're a coach, you can use your camcorder to study an athlete's performance to see what was good and what can be improved. A figure skating coach will shoot the skater's entire program. A football coach will want to shoot the team's entire practice. In the case of the high jump, as illustrated here, the coach will want to shoot all of the jumps, each from a different angle starting from the set to the landing.

If you're a racing fan, you may want to shoot an entire cassette of the day's race activities so you can relive the whole event later.

Shooting for Editing

All of the tips you've received so far are designed for "editing in the camera." If you are adventuresome, you'll want to try editing your videotape which will require you to increase the length of the shots you make and the amount of tape you shoot.

Unfortunately, there's no easy way to effectively edit videotape without the proper equipment. Unlike film that could be physically cut and glued back together, videotape must be edited electronically, using two VCR's. (Your camcorder can be used as one VCR.) You can do some very rough editing with two VCR's, but, to make precise edits, an edit controller must be added to the system to control the VCR's. And the "record" machine must have a flying erase head for glitch-free edits.

If you plan to do "post-production" editing, you won't want to "edit in the camera." Instead, you'll want to over-shoot. Remember this obvious and simple truth: If you don't shoot it, you can't edit it!

When planning to edit, extend each shot: shoot three or four seconds more at the beginning and the end of each shot. Shoot as much videotape as you want, knowing you're going to cut it down. Many of the shots will be made just in case something interesting happens.

Going back to the example of the family reunion, shoot a half hour of grandma playing with the baby so you can edit it down to a couple of minutes of the best shots. Shoot every minute of the youngster playing baseball so you won't miss that great catch, or sneaky bunt.

Chapter Eight

How to Tell a Story with Your Camcorder

Until now, the emphasis of this book has been on individual shots. Now, it's time to take the big step and put together a series of shots in a logical sequence to tell a story. The ideal way is by editing, a rather demanding procedure that requires time, the right equipment, and the desire. Sophisticated editing systems are still too expensive for the average home videomaker, and most people don't want to take the time to edit their videotape anyway.

However, you can shoot interesting and enjoyable home videos without editing. It's called "editing in the camera." The expression comes from an old newsfilm technique. Movie film comes in a light-tight metal can and to "edit in the can" means to shoot the film, have it processed, and show it on the air unedited. Such a practice was only done when a news cameraman was under a tight deadline.

While "editing in the can" isn't common practice in the news business, it is an art and a valuable technique that can be learned by the home videomaker. And even though it may sound difficult, "editing in the camera" can become your strong suit with some practice and a little forethought, and the results can be quite acceptable. When you learn how to "edit in the camera" you'll be able to string together a series of shots that fit well together, a series of shots that flow from shot to shot without jarring scene changes and unwanted feet and tree tops.

Forget the Script

Most books on shooting home videos go into great detail about writing a script before shooting an event. Not this book. I am not an advocate of the written script when it comes to home videos.

You may find it fun to write a script, and play producer, director, cameraman, soundman, and lighting technician for your first and perhaps even your second production. But before long, the time-consuming task will become as boring as some of the home video you've seen and as confining as a pair of handcuffs.

Imagine trying to follow a script as you shoot your next family vacation, or even a simple event such as a picnic. It's virtually impossible because people are unpredictable, even the ones you know best.

You're much better off ready to shoot whatever happens, when it happens. Not only will you get more spontaneous and interesting video, you'll enjoy your vacation or the event you're attending.

Don't get me wrong. I'm not categorically putting thumbs down on a script. If you're taping a production that has a specific message for a specific purpose where the words and the pictures must be exact, then write and stick to a script. But for 99 percent of your home videos, forget the script.

Try an Outline Instead of a Script

Just because I recommend that you forget a script, it doesn't mean I don't want you to plan ahead. Instead of writing a script, try an outline. An outline is much easier to prepare and to follow. No matter what you're about to shoot, you have a rough idea of what you want as a result of your efforts. An outline will help you get there.

At first, you may want to put your outline on paper. After you develop the ability to think "motion pictures," you'll get the hang of it and be able to work easily with a mental outline. A well thought-out mental outline will guide you through any shooting situation and allow you the needed flexibility. You can easily add the unexpected or delete the dull and boring at a moment's notice.

Here is an outline I would use to shoot Jimmy's birthday party.

1. Set-up
2. Games
3. Presents
4. Cake and Ice Cream
5. Good-byes

As you can see, it's very brief and that makes it extremely flexible allowing me to capture the little things that happen unexpectedly.

You can make your outline as detailed as necessary to keep you from forgetting the important elements but keep it as simple as possible to allow for the unexpected.

Building Blocks — The Basic Shots of a Movie

Editing in the camera is much like playing with childrens' building blocks. These building blocks let you ad lib your way smoothly through any situation. To explain, I'll use Jimmy's birthday party. Keep in mind these same shots work in shooting any situation; each shot and situation I explain can be transcribed and used to shoot similar scenes and series of shots. Try it and see how effective the suggestions are. First, there are three key shots that are the basic building blocks of any movie: wide shots, medium shots, and close-ups.

WIDE SHOT — A "wide shot" is a story-telling shot. It's made with your zoom lens at its wide-angle setting. A wide shot shows as much of the situation as can be put into one shot. At Jimmy's birthday party, the wide shot will show all the kids sitting around the table waiting for mom to bring in the cake and candles.

MEDIUM SHOT — A "medium shot" concentrates on the main subject but shows some of the immediate surroundings. The zoom lens is set at a narrower angle of view or the camcorder is physically moved closer to the subject. The medium shot in this situation will show mom setting the cake on the table in front of the birthday boy.

CLOSE-UP — A "tight shot" or close-up shows the details of the situation. The zoom lens is set at or near its maximum telephoto setting, or the camcorder is physically moved very close to the subject. The tight shot frames only the main subject and shows the expression on the child's face as he blows out the candles.

More Building Blocks — Connecting Links

When you watch a movie in a theater every shot seems to flow smoothly from one scene to another to another. There are no abrupt scene changes, no jumping from one shot to another.

It's not difficult to make your video flow just as smoothly as you change from scene to scene. It's like fitting one piece of a puzzle to another until you've formed one entire side of the puzzle's border.

Making your video flow smoothly from scene to scene is especially easy when each shot is of a different subject and in a different location. Looking at the tape is like looking at a carefully sorted stack of pictures, only motion has been added.

The abrupt scene changes are created when the same subjects appear in every shot, such as the cake cutting sequence we'll shoot at Jimmy's birthday party. To eliminate the jarring scene changes, we'll use some simple connecting shots and some changes in camera angles.

Avoiding Jump Cuts

Two shots of the same scene and the same people made back to back with an interval of time in between is called a "jump cut." Although the background is the same, some of the people in the shot will be in different positions and doing different things. Others may appear in one shot and not the other, making it seem as if them magically disappeared.

A typical jump cut would occur when a shot of the kids sitting around the table waiting for the birthday cake is followed immediately by a shot from the same camera position of mom standing next to the birthday boy as he blows out the candles. Such a jump cut is jarring to the viewer and can be avoided by using any one of a number of different and easy-to-use techniques:

The Cutaway Shot

You've seen a "cutaway" shot used when watching a TV news program when an interview is edited for time or content. The cutaway is a shot of the same scene from a different angle and is inserted in between the two similar shots. The cutaway eliminates the startling jump in the video created by the lapse of time between the two similar shots. It also helps reduce the amount of video you might shoot if you held the shot until all the action unfolded, from the beginning of the first shot to the end of the second shot.

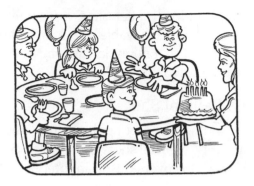

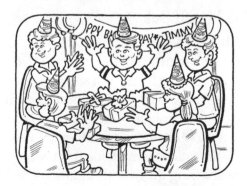

Here's how you can use a cutaway. First, frame up a wide shot of the kids sitting around the table with the birthday boy as the center of attention and roll

seven to ten seconds of video. Next, change camera positions so you're looking at the kids around the table from over Jimmy's shoulder. Roll the tape just before mom brings in the cake. Pause the tape after she sets the cake on the table. Now, return to the original camera position and frame a medium shot of Jimmy, mom, and the cake and roll the tape until he blows out the candles.

Even though the kids may be in different positions and doing different things in each of the three shots, the extreme change in camera angles will make it barely noticeable. By using the cutaway, you now have three smoothly flowing shots instead of two shots with an abrupt and jarring jump. The effect will give the impression that the video was shot with two cameras and the 20

seconds of lively, interesting video will be much more enjoyable than a long and boring shot that might last as long as a minute or two.

The Neutral Shot

Another connecting shot is the "neutral shot." Neutral shots are also used in TV news to cover edits in an interview. A neutral shot is similar to the cutaway in that it is used to separate two similar shots and eliminate a jump cut. A neutral shot is a shot of something associated with the situation, but not a part of the two scenes.

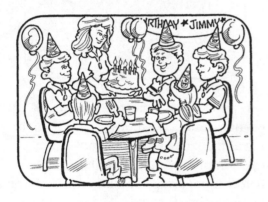

Here's an example of a neutral shot. First, make a wide shot of the kids sitting around the table with the birthday boy as the center of action. Roll the tape for a seven to ten second shot. Next, frame a shot of grandpa watching the action and roll the tape for a four to five second shot. Now, frame up a shot of Jimmy, mom and the cake and roll the tape until after Jimmy blows out the candles.

Again, you have eliminated an abrupt and jarring scene change and have created a smooth flowing sequence of video. Neutral shots are easy to find. Just be sure each neutral has some relationship to the situation you're shooting.

The Match Cut

It's not always necessary to use a cutaway or a neutral shot in between two scenes. A "match cut" is a simple and very effective way to make two shots fit. I use this technique more than any other when shooting video for either TV news or home videos. A match cut is a wide shot showing the overall situation followed by a tight shot of a particular point of interest in the wide shot.

Here's an example of a match cut. Frame up a wide shot of the kids around the table and roll the tape. Keep the tape rolling until mom sets the cake down on the table. After pausing the tape, kneel down and frame a tight shot showing the face of Jimmy and the cake with the candles. Now, roll the tape until after he has blown out the candles. Next, frame up a

wide shot and roll the tape to get the reaction of every one around the table.

The three shots, although the boy may not be in the exact same position in each of the shots, will fit together giving you a smooth flowing 20 seconds of video.

The Set-Up Shot

There's one more kind of shot we need to add to our bag of visual tricks. It's the "set-up shot." Every good story has a distinct beginning and every sequence of shots in a movie has an "establishing shot" or a "set-up shot." The set-up shot helps make it visually clear to the viewer what he or she is about to see. The set-up shot can be a sign, or a wide shot of a familiar scene, or a tight shot showing the detail of a single item.

Examples of set-up shots for our birthday party could be a close-up of the cake as mom writes the child's name on the icing. It could be a wide shot of the outside of the house with a "Happy Birthday" banner announcing the occasion to the world. Or it could be a medium shot of the pile of birthday presents.

Putting It All Together

Combine the building blocks with the mental outline and you can put together a series of shots that tell an entertaining and interesting story without the restrictions of a script. My goal is to shoot ten good minutes of action because I'll never watch two hours of Jimmy's birthday party ten years from now. To put together a pleasing series of

shots and keep the overall length to a minimum will take a little practice but the more you practice the better you'll become.

Professional producers of TV commercials and programs sometimes use the storyboard concept to present their ideas for approval before going into production. I'll use the storyboard approach here to give you an idea of how to put together a sequence of shots that flow smoothly from beginning to end.

The following is a storyboard for a portion of the birthday party video and will show you how the different kinds of shots and the sequence of those shots tell the story.

1. *Set-up shot* — Close-up shot of the party invitation. This set-up shot serves as a title for the birthday video. (If it's a costume party, you may want to follow with shots of the guests as they arrive.)

2. *Wide shot* — Kids playing a game with Jimmy as the center of attention. The wide shot shows what is going on and where.

3. *Tight shot* — A match cut showing the expressions on the face of the birthday boy. The combination of wide and tight shots work as a match cut and help shorten the video without destroying the content.

4. *Wide shot* — Kids playing the game from a different angle, in this case from over Jimmy's shoulder. This is another match cut that allows me to shoot more of the fun and games.

5. *Tight shot* — Neutral shot of mom watching the kids play. This shot not only shows mom is enjoying the party but helps keep the video from being too long.

6. *Medium shot* — Shot of the game's winner showing his or her reaction.

7. *Set-up shot* — Medium shot of pile of birthday presents. This set-up shot is a visual bridge between the games and the presents.

8. *Wide shot* — Kids sitting in a circle.

9. *Wide shot* — Cutaway shot from over birthday boy's shoulder showing a friend handing him a present.

10. *Tight shot* — Close-up of hands untying the bow on the package with a zoom back to a wider shot showing the child's reaction as he holds up a new toy.

11. *Neutral shot* — Medium shot of grandpa watching.

12. *Wide shot* — Shot of all the kids watching as the birthday boy opens another package.

13. *Neutral shot* — Close-up shot of the child who brought the present saying, "I hope you like it."

14. *Tight shots* — A series of close-up shots showing each child at the party. Since each shot is different with a different background they will match without a jump in the video. (If you want to shoot more presents being opened, use the same shot pattern as described in shots 10 through 13 and using cutaways, match cuts and neutral shots.)

15. *Tight shot* — Close-up shot of the birthday cake as mom lights the last couple of candles. This works as a transition shot from the presents to the cake and candles.

16. *Wide shot* — All the kids around the table with the birthday boy as the center of attention as mom brings in the cake. The wide shot shows everyone and what they are doing.

17. *Match cut* — Close-up shot of mom saying "Make a wish." This shot not only brings mom into the picture but helps cut down on the overall length of the production.

18. *Medium shot* — Birthday boy blowing out the candles and reacting to the accomplishment.

19. *Neutral shot* — Close-up of guest with ice cream and cake all over the face. This shot takes the viewer away from the center of attraction and shows what others are doing. It can be followed by close-up shots of other kids who have made a mess.

20. *Tight shot* — Close-up shot of dog licking up spilt ice cream and cake on edge of table.

21. *Tight shot* — Close-up of crumpled up wrapping paper and gift tag with a zoom out to a wide shot showing the mess left behind after the party's over.

22. *Wide shot* — kids saying goodbye
 and walking out the door.

Be Concise

In movie-making, as in speech, it
pays to be concise. Say what you want to
say, clearly and briefly. That's the most
effective way to get your message across.
Using the cutaway, the match cut, and
the neutral will give you a smooth flow-
ing sequence of shots.

Any given situation may take several
minutes to unfold, but by using cut-
aways, match cuts and neutrals as
connecting shots, you can record the situ-
ation in a minute or less. As a result,
your viewers will get all the information
they need to understand your story and
still enjoy the video.

Pause the tape as soon as the child
pulls the bow from the package. Next,
make a neutral shot of grandpa watch-
ing. When you turn back to the birthday
boy wait to roll the tape until just before
he opens the box and continue to roll
until after Jimmy holds up the present
for everyone to see.

Using the techniques I have
explained in this chapter should make it
easy for you to put together a series of
shots that not only tell a story but enter-
tain as well. And it should now be quite
clear that holding the camcorder still and
steady as the action takes place in front
of the lens makes better video. In fact, if
you have used your camcorder to re-
create my examples, you should find it

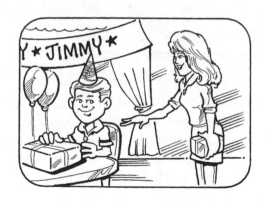

Clear and concise video also
depends on proper timing. For exam-
ple, roll the tape just before the child is
handed a gift to open. If you roll the
tape too late, you'll lose the "presenta-
tion." If you roll the tape too soon you
will have shot more of the event than
you need.

easier to hold the camcorder still and steady than to point it indiscriminately at anything and everything that meets your fancy.

Editing in the camcorder (or editing as you shoot) really isn't difficult. With a little practice, it will become easier and your videos will become smoother and more interesting.

Fortunately, videotape is cheap and you can practice at virtually no cost. After all you can erase the tape and use it over and over again.

Chapter Nine

Three More Stories and How to Shoot Them

You may think that a simple and highly formulated method of shooting home video will produce predictable and uninteresting results. Quite to the contrary. By using an easy and simple shooting style and sticking to the shot combinations I recommend, your videos will become much more interesting. You will have eliminated most of the out-of-focus shots, the random pans and incessant zooming, and the unending shots without meaning. Instead, you and your viewers will become totally absorbed in the story you're telling or the event you've recorded no matter what the subject might be.

Three Kinds of Shooting Situations

For all practical purposes you can lump every situation you face with a camcorder into one of three categories. They are "the planned but unpredictable" occasion, "the unplanned and unpredictable" situation, and "the programmed" event."

Planned but Unpredictable

The birthday party, as outlined in Chapter Eight, comes under the heading of "the planned but unpredictable" occasion. The "planned" portions are those you know are going to occur, such as games, gifts, cake, and ice cream. The kids, as you can see, are the "unpredictable" part. Although you may know what is planned to take place during the party, you never know what someone will do to make things exciting and entertaining. You just have to be ready with your camcorder for the unexpected.

Other events that fall into this category are: Christmas morning; wedding showers and receptions; graduation parties; and most family gatherings. If you review the birthday party outline, you should see how the different shot sequences fit these other situations.

Unplanned and Unpredictable

The second type of situation you're likely to face is "the unplanned and unpredictable" situation. Many of the situations in this category arise at a moment's notice which means you'll have to grab the camcorder and shoot, such as baby's first step and the dog's encounter with a skunk. Other home videos that fall into this category are: the family vacation; the backyard barbecue; the family reunion; a trip to the zoo; and a day at an amusement park.

A Day at the Amusement Park

The annual excursion to the area theme park is a day filled with great video possibilities at every turn and you'll be tempted to shoot every ride and every reaction. You might think it should come under "the planned" category since you and your family have been there before, but the only thing you can plan in advance is the fact that the event is going to take place. Everything else is up for grabs because the people involved are unpredictable.

To show you how to use the various shots and combination of shots described in Chapter Eight, I'll outline three different events; a ride on the super soaker log ride, a costumed character entertaining a bunch of kids on the midway, and a picnic lunch by the lake.

As you visualize the results of this outline, remember I'm showing you only a few of the picture possibilities for each sequence. You can add shots and a series of shots as you see fit and as the situation dictates.

I have not pointed out the cutaways, neutrals and match cuts in this scenario for a reason. To help you learn my simple and highly formulated system, I want you to use your pencil and see if you can figure which is which.

1. *Wide shot* of the sign at the gate of the theme park or a close-up of the pre-purchased tickets as a title shot for the day's excitement.

2. *Wide shot* of the family closing the car trunk and walking toward the camera carrying picnic baskets and coolers across the parking lot. Let them walk by and out of the shot before pausing the video.

3. *Wide shot* of the family from behind as they walk up to and through the gate. Let them disappear into the park.

4. *Close-up* of the sign in front of the log ride. This shot helps orient the viewer and make the video easier to comprehend.

5. *Wide shot* of the family hurrying up to the line in front of the ride.

6. *Wide shot* of the log ride to show the viewer what the ride looks like.

7. *Close-up* of the log with the kids and dad as it climbs up the first hill. Hold the shot until the log is out of sight.

8. *Wide shot* of people watching and reacting to the ride.

9. *Wide shot* of the super soaker hill as a log filled with people appears at the top. Since it's difficult to see who's in the log until it comes into sight at the top of the hill, pause the tape until you spot your family.

10. *Close-up* shot of the log with your family. Follow the action as the log slides down the run and everyone is soaked to the skin.

11. *Wide shot* of the exit with the family running out soaking wet and reacting to the thrill of the ride.

12. *Wide shot* of midway showing the crowd and the rides as you move from one sequence to the next.

13. *Wide shot* from behind and to the side of a costumed character showing him/her entertaining kids on the midway.

14. *Wide shot* from behind and to the side of your kids and mom watching the action.

15. *Medium shot* from behind and to the side of the character of your kids watching the fun. If necessary to keep everyone in the shot, zoom out to a wide shot as they walk up for their turn. Hold the shot for their reaction.

17. *Wide shot* from behind and to the side of the character showing the kids faces. Again get close enough to pick up the sound. Hold the shot until the kids walk away.

16. *Wide shot* from over the kids shoulder to the character talking with them. If you arc close enough, your built-in microphone will pick up the sound and the conversation.

18. *Wide shot* of the picnic area around the lake as you switch from one sequence to another. You can pan to show the size of the area and the number of people.

19. *Wide shot* of the family spreading the blanket and preparing the picnic.

20. *Medium shot* of mom unloading the basket. The audio should be good as you are close enough for the built-in microphone to pick up the sound.

21. *Wide shot* from behind and to the side of mom as she hands out the sandwiches.

22. *Close-up* of the picnic basket as mom pulls out the food.

23. *Close-up* of one of the kids eating a sandwich.

24. *Close-up* of another kid eating.

25. *Medium shot* of mom handing dad a sandwich. Since dad is shooting the video he reaches in front of the lens to take the sandwich.

26. *Close-up* of dad as he eats the sandwich. Mom takes the camcorder to make this shot so no one is left out of the video.

27. *Wide shot* of kids and dad on the blanket eating lunch.

28. *Close-up* of mom taking a cold drink.

29. *Wide shot* of kids and mom as she continues to sip on the drink.

30. *Wide shot* of the picnic grounds and the lake.

31. *Wide shot* from behind the car. Kids walking toward camcorder dragging the basket and cooler tired from the busy day.

Now you can try adding after scene 11 a series of shots centered on any other ride that's a family favorite. While you're at it, outline any other sequence of shots based on your memory of past visits to the theme park such as a stop at the ice cream stand, feeding the ducks, and buying the souvenirs. These sequences should also be inserted after scene 17 and/or scene 30.

The Family Vacation Trip

The family vacation is another unplanned and unpredictable situation and one you can burn up more video-tape than on any other subject. All the things you see and do are new and different so you'll be tempted to shoot everything.

It's easy to come home with three or four two-hour cassettes detailing every turn of the road. By using the techniques I have described in this book, not only will you be able to show more, but you'll shoot a lot less videotape.

For our example, I'll outline a visit to an artist's market like the one near the Sacre Cour in the Momarte district of Paris. Keep in mind this is an outline taken from a series of shots I made on an ad lib basis as I reacted to what I saw.

1. *Set-up shot* of a sign that says "Artists Market." This is the title shot for this scenario.

2. *Wide establishing shot* of the market place from a nearby high point such as a park bench or the window of a building. If the market place is too big to get in frame, you can pan using the technique explained in Chapter Two. This shot gives the viewer a better idea of the setting.

3. *Medium shot* of artist #1 painting on a canvas from over the artist's shoulder.

4. *A match cut close-up* of artist #1's hand and brush as he strokes the canvas. This scene is made from the same location and the action is a continuation of the action in Scene 3.

5. *Close-up* of artist #1's face from behind and to the side of the easel to show his intensity.

6. *A medium shot* of a couple watching artist #1 at work.

7. *Medium shot* of artist #1 and canvas similar to scene #3.

8. *Wide shot* of the marketplace showing general activity, including several artists at work.

9. *Wide shot* of artist #2 and model from over the artist's shoulder.

10. *A cutaway wide shot* of model and artist #2 from over model's shoulder, showing the artist's face.

11. *Wide shot* of artist #2 and model from over the artist's shoulder, similar to shot number 9 above.

12. *A match cut close-up* of the model's face.

13. *Close-up* of artist #2 drawing, putting a finishing touch to his/her work—with a zoom out to a wide shot to include the model walking around the canvas to see the results.

14. *Medium shot* of artist #2 and model reacting to the drawing.

15. *Wide shot* of artist #3 and couple buying a piece of pottery, from over the couple's shoulder.

16. *A match cut close-up* of the pottery.

17. *Wide shot* of couple and artist #3 from over artist's shoulder.

18. *Close-up* of the artist #3's face as he says, "It's one of a kind." Then zoom out to a wide shot of the couple paying the artist, from over the artist's shoulder. Hold the shot

until the couple picks up the piece of pottery and walks out of the shot.

19. *Wide shot* of couple with piece of pottery sitting at a table in a sidewalk cafe.

A variety of shots can be added to this scenario to add to the presentation. For example, different shots of other artists working and selling their work can be inserted between scenes 8 and 9. A series of close-ups of the various works of art can be inserted between scenes 13 and 14. And any other artist of particular interest can be featured by using a series of shots similar to the sequences I have described.

Again, this is an unplanned event but, by carefully observing what is taking place, you should be able to capture five minutes of nicely framed and in-focus video with crisp clear sound.

The Programmed Event

The third category is "the programmed" event and is probably the easiest of all situations to shoot. The action takes place in a confined area such as on a stage or an athletic field and follows a well-planned schedule. All you have to do is focus, frame the shot, and

roll tape at the right time. The dance recital, school play, political speech, graduation, a wedding, and a sports event all fall under this heading.

The Kids' Performance

The artistic performances of your children will remain in your memory forever and a dance recital is a good example of the planned event. When you walk through the door of the recital hall, you know what is going to happen, when it will happen, and what you want to shoot. But, as in all presentations such as speeches, artistic performances, and school plays, there are a number of decisions to make.

The first is how much tape to shoot. In this case, tape consumption is based on your child's participation. For this example, assume your daughter will appear in a group performance and in a solo effort. Assuming each number is around three minutes long the entire videotape should be no more than eight or nine minutes. If you're shooting this recital for the family archives, the performance of other kids won't mean much years from now, so don't shoot them. If close friends or relatives of your daughter are performing, you may want to record segments of their performances.

The next decision is your shooting positions. The best shot of the dance numbers is from behind the last row of seats with the camcorder high enough to keep the heads of the audience out of the shot. A balcony is also a good

advantage point. For lengthy performances use a tripod. For the other shots in the outline you'll have to hand-hold the camcorder.

You also need to figure a way to "mike" the sound. You'll get the best audio by using an extension mike set in front to the speaker of the music system. When you move from the tripod position, unplug the extension mike and use the built-in mike for the sound.

1. *Close-up shot* of the dance recital program. This serves as a title shot for the production.

2. *Medium shot* of mom helping your daughter with the last minute costume, make-up, and hair approval from behind and to one side of your daughter.

3. *Close-up shot* of daughter from behind and to the side of mom. Hold the shot until mom gives her a good luck kiss and walks away.

4. *Wide shot* of audience applauding from the edge of the stage.

5. *Wide shot* of the stage with dance troupe lined up ready to dance. After you have established the presence of the large group zoom into a full length shot of your daughter. Thirty seconds before the end of the number zoom out to a wide shot. If it's a small dance line, you may want to stay wide for the entire number.

6. *Wide shot* of audience applauding from the edge of the stage. Since it will be difficult to remove the camcorder from the tripod and move from the back to the front of the auditorium during the applause, It'll be easier to shoot the applause at the end of the next number.

7. *Close-up* of mom or dad applauding. This shot may also have to be made at the conclusion of the next number.

8. *Close-up* of the dance master introducing your daughter's performance.

9. *Wide shot* of the stage from the back of the auditorium to show your daughter in the set. As you continue to roll tape, zoom into your daughter for her solo and follow her for the duration of the performance. At the end of the number, zoom back to show the audience applauding and the curtsy.

10. *Wide shot* of dance troupe back stage.

11. *Medium shot* of daughter with mom walking up to extend her congratulations.

The outlines of these three situations are only suggestions of the way each might be approached. From them you should get a good idea how to go about taping almost any situation. It would be nice to be able to give you a single basic outline to follow for every situation, but that's impossible because every situation is a little different and requires different techniques. By using these outlines as a guide and by planning ahead, you'll be able to face any situation with ease.

Chapter Ten

Let There Be Light — The Right Kind of Light

We do not see an object itself. What we see is light reflecting off an object. Therefore, we can not see without light and neither can your camcorder.

The easiest way to explain this is that during daylight hours you can look out your window and see the house across the street. But after dark, you can't see the house unless it is lit by a street light or a full moon. Even under those conditions you can't see the house very well.

The plain and simple fact is: You need light to see, and you need light to make home videos.

Up to a point, the brighter the light, the easier it is for the eye and the camera to see. But, there's a lot more to light than meets the eye. There are qualities like softness, hardness, and direction that affect a picture. Light also has color and different light sources create light of different colors.

Your camcorder has two automatic features that control light. The "automatic white-balance control" works to give you perfect color under almost any kind of light and the "automatic exposure control" electronically sets the correct exposure.

While these automatic controls are extremely reliable, they aren't entirely fool-proof. Perfect video will depend on how you use and control the light sources available to you. By following the advice in this chapter, you'll see a big difference in the color quality of your videos.

White Balance

Older video cameras (or camcorders) had to be manually "white balanced" before you shot, and whenever you moved from one light source to another. If you forgot to "white balance" and went from inside to outdoors, the outdoor video would have an eerie blue cast to it. If you still have a video camera that requires manual white balancing, you may want to re-read the instruction

manual especially if you don't use the camcorder very often.

Newer camcorders automatically adjust the "white balance" for the best color so you'll rarely have to worry. About the only time you'll have a problem with white balance is when you're shooting a scene with mixed light sources, such as daylight coming through a window and tungsten light coming from conventional light bulbs. In a situation like this, a portion of your picture will be off-color.

If your camcorder "sees" and balances to the color given off by the light bulb, the area of the picture lit by daylight will have a bluish cast. If your camcorder balances to the daylight area of the picture, the portion lit by the light bulb will be a warm orange-yellow color.

Another problem can arise if you don't understand the symbols on your camcorder's white balance controls. Some camcorders have pre-set manual white balance settings. These settings are usually marked by a little sun or a light bulb or the words "indoors" and "outdoors." Beware! These symbols refer to the type of light and not the physical location.

For example, if you're shooting a party on the patio at night using incandescent light, use the setting represented by the light bulb or labeled "indoors" even though you're outdoors. If you're shooting indoors using only the daylight coming through the window, use the setting represented by the sun or labeled "daylight" even though you're indoors.

Learn to Recognize the Color of Light

Even though your camcorder has automatic white balance learning to recognize the color of the light falling on your subject will help improve the quality of your video. Here's a chart showing the most common light sources you will encounter and how the different ones vary in color according to their "color temperature" measured in degrees Kelvin.

DAYLIGHT — The color of daylight depends on the time of day. On a sunny day the light from mid-morning to mid-afternoon is the light we use as a standard for white light. At sunrise daylight has a cool, bluish tinge and at sunset the light is usually more reddish or warmer looking. Open shade, where your subject is lit only by light from the blue sky, is cool-looking or bluish. An overcast sky also tends to give off a bluish light.

INDOOR LIGHT — The color of light from tungsten-filament or incandescent light bulbs is a warm yellow-orange to red. The lower the wattage of the bulb the redder the color. Fluorescent lights can vary from one end of the color spectrum to the other. Cool-white or daylight flourescents are a close match to the outdoor light of mid-day. Warm-white flourescents are closer to the light of a incandescent light bulb.

MERCURY AND SODIUM VAPOR LIGHTS — You'll find these kind of lights in business districts and in sports arenas. They are not the best kind of light for good color. Mercury vapor lights give off a strange greenish color while sodium vapor lights cast a bright and brownish-yellow glow. Fortunately, an increasing number of sports facilities, especially those where events are telecast, are using lights that are balanced for daylight.

The Mysterious LUX Rating

The amount of light entering the lens of your camcorder is measured in LUX. Manufacturers rate a camcorder's ability to record in low light in LUX. A little over 10 LUX is equal to one foot-candle; one foot-candle is the amount of light from one candle that falls on an object one foot away.

Don't get the idea that you can light a room with a couple of candles and get bright colors and good contrast with your low LUX camcorder. It just won't happen. A camcorder with a low LUX rating will give you an image in most low light situations, but a low LUX rating doesn't promise you a GOOD picture under low light.

In daylight, the sun provides plenty of light for excellent color and contrast. But, indoors at night, a light source must be placed correctly to get good video.

The intensity of light drops off dramatically as a light source is moved away from the subject. For example, if

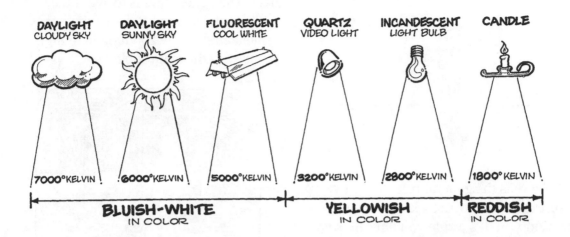

DAYLIGHT CLOUDY SKY	DAYLIGHT SUNNY SKY	FLUORESCENT COOL WHITE	QUARTZ VIDEO LIGHT	INCANDESCENT LIGHT BULB	CANDLE
7000°KELVIN	6000°KELVIN	5000°KELVIN	3200°KELVIN	2800°KELVIN	1800°KELVIN

BLUISH-WHITE IN COLOR **YELLOWISH** IN COLOR **REDDISH** IN COLOR

you move a light from four feet to eight feet from the subject, the light intensity will drop by one-fourth. The above illustration shows how dramatic light drops off with distance.

Automatic Exposure Control

The automatic exposure control on your camcorder measures the amount of light reflected off an object and into the camcorder. The lens opening, or iris, is then electronically adjusted for the correct exposure. In most situations, you have a full range of colors and shades and the automatic exposure control will give you a properly exposed picture. But, when you're confronted with extreme differences in contrast or brightness, it will be difficult to see detail in the brightest and darkest parts of the picture.

Some camcorders let you manually override the automatic exposure control so you can adjust the lens opening to your satisfaction.

Since the lens opening is electronic and not mechanical like the f-stops on a 35mm still camera, manually controlling the exposure is not easy. Many camcorders have a limited adjustment called a backlight control. It allows you to push a button to momentarily increase the exposure on your subject when the background is brighter than the foreground.

Outdoor Lighting

The automatic exposure control does make shooting video outdoors trouble-free. But there are some things to keep in mind.

the person, will be underexposed and dark. The easiest cure is to avoid the white house, either by changing your camera angle or by zooming in to fill the frame with the main subject.

Here is the general rule to live by: For the best exposures, keep the sun behind you. It's a rule you'll recall from shooting snapshots with a still camera.

OVEREXPOSURE — When your subject is in front of a dominant, dark background the exposure will be based mainly on the background. The result will be overexposure: the subject will be too bright and washed out. Again, changing the composition is the easiest cure.

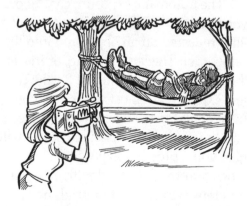

UNDEREXPOSURE — A white, sunlit house filling the frame in the background will create a false exposure reading. The main subject in this picture,

An even more difficult exposure problem is created when your subject is in the shade and the background is in bright sun or vice versa. In either case move your subject or try to put the subject in front of a similarly lit background.

A sandy beach or a snow scene in bright sunlight can cause serious exposure problems, too. The camera will read the bright sun reflecting off the sand or the snow and your subject will be dark.

Try to introduce some dark tones to the pictures such as green leaves, blue sky, or dark clothing.

BACKLIGHTING — A strong light source, such as the sun, directly behind a subject, can "fool" the automatic exposure control. For a more accurate exposure, move physically farther from your subject, using the zoom to get you "closer" and use a background that's lit at about the same brightness as your subject. To keep the sun from hitting your lens and washing out the picture, you may have to use your hand as a lens shade. Be careful not to get your hand in the picture.

Indoor Lighting

There is seldom enough light, daylight, or artificial light, in most family rooms, churches, and banquet halls, to make good pictures. What light there is, is rarely just right. For example, sunlight pouring through a window can create extreme contrast and the room lights may light up a portion of the room and leave the rest of the room in comparative darkness.

But wait a minute! The salesman said your camcorder will make great pictures in almost no light at all. And he probably quoted an impressive LUX rating in trying to prove his point. Unfortunately, as I explained earlier in this chapter, it just isn't true.

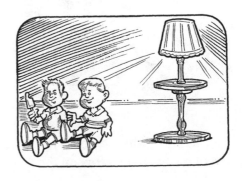

The kids playing in the center of the family room may look good to your eye, but there's probably not enough light to produce a good picture.

Learn to recognize poor lighting conditions and add some light when and where necessary. Your camcorder will take care of the rest with its automatic exposure control. The automatic exposure control on some camcorders will even tell you when there's not enough light. A small warning light or symbol will flash in the viewfinder when the light is too low to shoot good quality video.

You can add light to a scene by using any one of a variety of lights on the market. Your video or camera store has both plug-in and rechargeable battery-operated lights. You can even make your own movie lights for only a few dollars. Buy a couple of good, old worklights with alligator clamps and aluminum reflectors and put 150 watt bulbs in them. Or, buy just the sockets and alligator clamps and use reflector flood bulbs.

You can use a floor lamp with a dimmer switch that uses a 500 watt quartz bulb to reflect light off the ceiling. Turn it up full and you'll have plenty of soft light to shoot videos anywhere in the room.

How Much Light is Enough

In most situations the two reflector floods with 150 watt bulbs directed toward the subject or the 500 watt quartz light bounced off the ceiling will light up the average-sized family room. Place the reflector floods as shown in the illustration, up high and on different sides of the room. Keep the lights behind you, as you would the sun. You can add a third reflector flood as a backlight to give depth to the video. However, be careful to keep it from shining in lens.

Larger rooms may require more lights. Banquet and meeting rooms are especially difficult to light because the existing light is designed to create a mood and is not intended for shooting video. A room with dark walls will require more light than a room with light-colored walls.

Lighting Techniques

Most of the lights made for video are made to attach to the accessory shoe on top of the camcorder. However, video from a camcorder-mounted light is flat-looking light and not very flattering to your subject. I prefer working with a couple of lights, clamped to objects such as the tops of doors, bookshelves, or suspended ceilings.

Compare the limitations of a camera-mounted light with the flexibility of a couple of well-placed clamp-on lights:

- A camcorder-mounted lights shine directly into the eyes, blinding the people in your video.

- Lights placed up high and away from the camcorder are less bothersome to your subjects' eyes, therefore your subjects will look more relaxed and comfortable.

- A camcorder-mounted light must be turned off between shots to keep the random movement of the camcorder and light from annoying people. The constant switching of the light on and off draws your subjects' attention to the camera and turns them into actors.

- Lights clamped up high can be left on the entire time, eliminating the on-off distraction thus making your videos much more natural.

- A camcorder-mounted light can create a distracting black shadow on the wall behind your subject.

- Lights placed up high eliminate those shadows.

- With a camcorder-mounted light, exposure will vary from shot to shot as the camera position and distance from the subject change.

- When the lights stay in the same place, the lighting remains constant, no matter where you place the camcorder.

- A plug-in camcorder-mounted light, with the cord dangling down your back, puts you in danger of tripping or strangling someone as you move. A light stand can be pulled over by a child on the floor or tripped over by someone who isn't paying attention.

- The safest light is the one clamped up and out of the way, with the cord "dressed" down so no one will trip and fall.

Some More Lighting Suggestions

There are some more ideas for better video with indoor lighting:

- The bigger the room, the higher the ceiling, and the darker the colors in the room, the more lights you will need. An empty room may have enough light, but fill that room with people wearing dark clothing and a lot of the light will be "eaten" up.

- If you're shooting in a dark hall, have a friend hold your light and move around with you. The light should be held as high as possible, and aimed over your shoulder toward the subject.

- Never shoot into a window. Your camcorder will read the bright daylight rather than the light on your subject producing a silhouette effect. Keep your back to windows and bright lights.

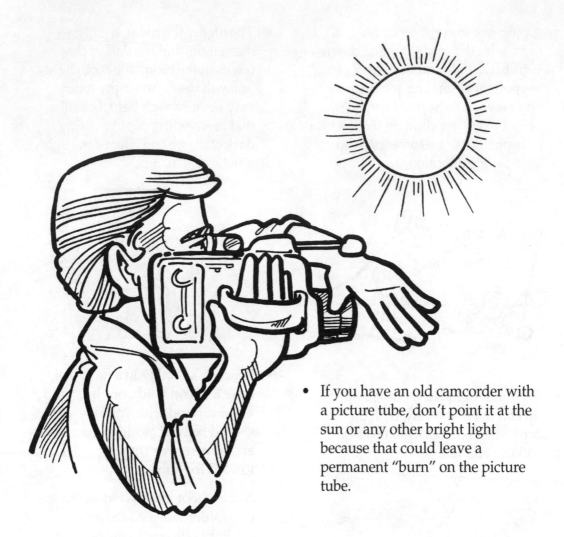

- If you have an old camcorder with a picture tube, don't point it at the sun or any other bright light because that could leave a permanent "burn" on the picture tube.

Chapter Eleven

Good Advice for Better Sound

As you record video, the camcorder's built-in microphone and automatic sound system records sound. In most cases, the system does a great job.

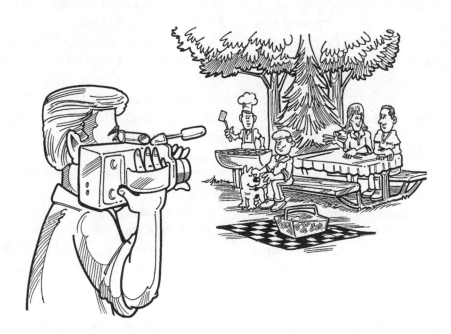

The built-in microphone is directional, designed to concentrate on sound coming from in front of the camcorder. The automatic gain control (AGC) adjusts the volume so the recorded sound will be loud enough to hear, but not so loud as to be distorted.

However, the system doesn't always provide perfect results. To understand the problems you'll encounter with AGC, you need to know a little about sound and the way your camcorder's "ears" work.

You can listen to a conversation even under less-than-ideal conditions. Even when background noise is very loud you can listen to a conversation because your brain lets you hear selectively. In other words, you can concentrate on what you want to hear and ignore what you don't. A good example is your ability to carry on a conversation while ignoring the TV.

Under ideal conditions, your camcorder can easily pick up a conversation from as far as 10 to 15 feet away. But, since you will seldom have ideal conditions, remember this rule: The louder the background noise, the worse the audio of the conversation. That's because your camcorder's electronics doesn't have the ability to "listen" selectively. A conversation in a room with the sound of the TV blaring away becomes a garbled mess and, outside, the noise from a speeding car, a power lawn mower, or an airplane will drown out any conversation.

Automatic Gain Control

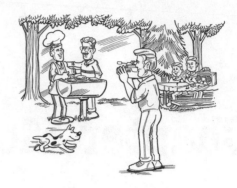

The automatic gain control sets the camcorder's volume to record the loudest sound it hears at 100 percent. All other sounds are recorded at proportionately lower levels depending on the loudness of the sounds.

If you're recording a robin and a dog barks, your video will be that of a barking bird. If you want to record a conversation and a truck goes by, the roar of the truck's engine can momentarily drown out the conversation.

Learn to be aware of the sound that is around you when you are shooting home videos.

For instance, if traffic noise is a problem, change your shooting position. Put the street to your back and point the lens and the mike away from the source of the annoying sound. You can also move farther away from the noise.

The music from a radio may sound nice to the ear as background music. However, on tape it may be loud enough to drown out the sound you want to hear. The solution is to turn off the music.

string of broken musical phrases. Unless the music is important and you intend to keep the tape rolling continuously, it's best to avoid shooting with background music altogether.

I'M A YANKEE DOODLE...

Auxiliary Microphones

You're not limited to using your camcorder's built-in microphone. Almost all camcorders have a place to plug in an auxiliary microphone and, at the same time, switch off the built-in mike.

There's an auxiliary mike made for almost every situation. Your camcorder retailer can help you select the right mike for the right situation.

OF MY UNCLE SAM...

For example, if you're trying to record a conversation and there is a lot of background noise, give one of the participants a hand-held mike on a long mike cable. Non-directional hand-held mikes have a pick-up range of a couple of feet.

TO RIDE A PONY...

Incidently, the music in the background will start and stop every time you start and stop the tape, giving you a

It is impossible to get good sound from the back of a large room with the camcorder's built-in mike. Try placing a hand mike on the podium. You can also set the hand mike in front of a sound system's loud speaker.

If the background noise is loud and you want to concentrate on a single source of sound, try a directional microphone. There are directional hand-mikes that have a pick-up range of two to three feet. Sound coming from beyond that range and from the side is virtually eliminated.

If you want to reach out and grab the explosive sounds of a football game from the sideline try a "shotgun" mike. It, too, is a directional microphone, but isn't limited to the short range of a directional hand mike.

A long mike cable can become a problem when you want to change camera positions while shooting a situation. A wireless microphone will free you of mike cables and let you move around with ease. Any kind of microphone can be connected to the tiny short-range radio transmitter to send the sound you want to record to an equally small receiver plugged into the extension mike plug on your camcorder.

If you want to use more than one mike at a time, you'll need a mike mixer. Plug all the mikes you're using into the mixer and plug the mixer into the camcorder or wireless transmitter. An audio mixer is especially convenient for a roundtable discussion or a school play.

Learn to Listen to the Sound You Hear

When I'm shooting video, I pay as much attention to the sound as I do to the picture. Sound is important because it brings the video to life.

Most of the sound you will record is called "wild sound." Wild sound is the ambient noise that is always in the background, sound or noise that you pay little attention to. It's traffic noise, the kids at play, crowd noise at the ballgame.

You usually won't record an actual conversation. Most conversations are too long to record, and too boring to be of much interest to your viewers.

WHAT A GREAT DAY FOR A PICNIC!

YES! IT IS! SURE GLAD IT DIDN'T RAIN!

OH! LOOK! YOU HAVE A FRIEND!

Most of the conversations will be one-liners from the people in your videos. This will require that you listen carefully to what is being said. It's difficult to know when someone is going to say something significant, but the more you shoot the better you will become at guessing when someone is going to say something you'll want to record.

Ideally, you'll roll the tape before someone says something and keep the tape rolling until the person has completed their thought. If you pause the tape before the end of a sentence or a phrase your audio will be confusing to the viewer.

If you really want to keep an ear on the sound you're recording, use an earphone. Some camcorders have a tiny built-in speaker to help you monitor the sound. In normal situations it's adequate, but in high noise situations it's useless.

Chapter Twelve

Other Uses for Home Video

Your camcorder is a useful and versatile piece of equipment, capable of doing a lot more than just shooting home videos of the kids and vacations.

Don't leave it in the closet to gather dust in between those special occasions. Use it! Some enterprising people have turned their investment in a camcorder into a money maker. Others have used it for personal purposes that save them money. Still others just have fun experimenting. You may already have discovered and attempted some useful applications for your camcorder, sometimes successfully, other times not.

In this chapter I'll tell you about a few of the other things your camcorder can do.

Transferring Slides and Film to Tape

There are professional services that will put your slides and movie film on videotape. The cost ranges from expensive to prohibitive, depending on the amount of film footage and the number of slides you want to transfer. You can save a lot of money if you do it yourself and, often, the results will be more to your satisfaction.

When you've finished the job, you'll be able to enjoy your slides and movies with the convenience of a rented movie rather than having to set up a projector and screen and darken the room.

THE SET-UP — The same basic setup is used to transfer both slides and film to videotape.

You need a slide or movie projector, a camcorder, and a tele-cine or film/slide converter. These converters contain a mirror that reflects the image from the projector onto a small, translucent screen. The camcorder is focused on the screen and records the image as it would any living scene you might shoot. Complete instructions are included with each converter.

If you want to save even more money and get just as good a result, forget the converter and use a piece of plain white cardboard. Project the image from the projector on the cardboard and shoot it with your camcorder as you would any live scene. Here's how to do it:

1. Buy a 20 by 24 inch piece of smooth, white illustration board.

2. Attach the illustration board to a wall at the same height as the projector.

3. Set the projector on a table at a distance where the image will almost fill the illustration board.

4. Put your camcorder on a tripod and set it at the same level as the projector lens. To prevent keystoning or image distortion, position the camcorder as close to the projector lens as possible.

5. Use your camcorder's AC power supply rather than a battery so you'll have plenty of power for the entire project.

6. Connect the camcorder to a TV set to make sure the color, focus, and framing are correct.

7. Darken the room so the image will show brightly on the screen.

8. Before loading the projector, turn on its light and manually white balance the camcorder.

9. Load the projector and focus the projector's image on the "screen."

10. Manually focus the camcorder on the projected image.

MAKE A TEST — Before you attempt to tape the whole project, make a test. Record a minute or two of film or a half dozen slides. Check the framing to make sure the TV screen doesn't cut off too much of the edges of the picture. If the videotaped image is washed out, it is over exposed. Either close the lens with the manual iris control or decrease the light from the projector.

SLIDE TO TAPE TRANSFER — When you're ready to transfer a batch of slides to videotape, follow these basic steps:

1. With the camcorder's lens cover in place or your hand over the lens, record 30 seconds of "black" at the beginning of the tape. This 30 seconds without video will give you a "clean" look at the beginning of the tape and gets you past the clear tape that connects the magnetic tape to the take-up reel of the cassette.

2. With the camcorder in "pause," load and focus a slide on the illustration board and frame and

focus the image in the camcorder's viewfinder.

3. Roll the tape for the desired time.

4. Pause the camcorder.

5. Change slides and repeat steps 1-4.

By pausing the camcorder between each slide, you won't see the slide change and any out-of-focus or mis-loaded slides when you view the videotape.

The advantage of using a piece of smooth, white illustration board rather than a tele-cine converter is the larger image you get to work with. The larger image allows you to selectively crop poorly-framed pictures for better composition. It also allows you to turn vertical slides into horizontal TV pictures.

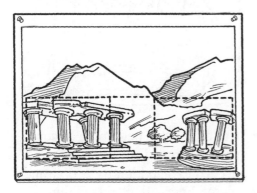

You can even pan and zoom to put a little "life" into your slides. However, before you're tempted to pan and zoom on every shot, read Chapter Two again!

FILM-TO-TAPE TRANSFER — The slide-to-tape and film-to-tape transfer methods are basically the same. However, edit the movie film before you begin the transfer to videotape.

There is one problem you may encounter when making a film-to-tape transfer. The picture on tape may have a pronounced flicker in it, even a "roll bar." This is because you're using two incompatible systems. The camcorder records 30 frames per second at 1/60th of a second. Eight millimeter movie film runs at 18 frames per second and different projectors have different shutter speeds. The slower the projector's shutter speed, the longer each image remains on the screen, making the picture more stable. If a projector gives you too much flutter, try using a dimmer switch to slow its speed.

ADDING SOUND — When you've transferred your slides or film into videotape try adding sound in the form of narration, music, or sound effects. To add an audio track your VCR must have the "audio dub" feature which allows you to record a sound track without disturbing the video. To prevent the mike from picking up the ambient noise during the transfer you can disable the mike by inserting a mini-pin plug in the accessory mike jack on the camcorder.

Write a script or make an outline from which you can ad lib the narration. Then record the voice track with the

audio dub feature as you watch the video on TV. If you want to add music only, plug your music system's output into the VCR's audio-in jack. If you want both narration and music you'll have to use an audio mixer to combine the two.

Before you attempt to add the audio to your film or slide transfer, read your VCR's instruction book and experiment with a practice tape.

Your Family Tree

Videotape can help you preserve your family's history and let you share it with others. No one wants to dismantle the family album to send the photos away for expensive copies. You can build a family video album for no more than the price of a videotape cassette, a make-shift copy stand, and some of your time.

The most convenient copy stand is similar to a photographic enlarger as it has a vertical column to support the camcorder and a horizontal baseboard as an easel. With such a system you can shoot single pictures or the entire album. Of course, the photo being copied must be flat.

If you don't have a copy stand, use a music stand or artist's easel to support the album or pictures and a tripod for the camcorder.

1. Connect the camcorder to your TV set to monitor the color, focus, and framing.

2. Place two lights, one on each side of the camcorder. The lights should be aimed at the photos at an angle of about 45 degrees to prevent glare from any glossy picture.

3. Focus and frame a picture.

4. Roll the tape for as much time as needed to fit any dialogue.

5. Repeat steps 3 - 4 for each picture.

DRESS UP YOUR PRODUCTION — Some pictures may be too small to get in close enough without showing the border or the easel. You can "dress up" the easel by preparing a montage of old, unwanted pictures. To make an attractive shot, simply place the picture you want to copy on top of this montage.

Here are some other ideas for turning your family album into a professional-looking presentation:

- Use titles at the beginning of your production and subtitles when needed to help identify people and places. End with credits to the

people who have helped you prepare the production.

• Use the camcorder's fade-in-fade-out feature to add separation between branches of the family tree.

• Conduct interviews with members of your family about times they remember. If you have pictures or video of the people or events you can use the "insert edit" feature of a VCR to add them to the tape.

• Don't forget that you need not limit your production to old snapshots. You can combine the pictures with your old 8mm movies, too.

When your video album is completed, have copies made and give them to family members. Keep the master tape in a safe deposit box for safe keeping. Update it after important family events such as births or reunions, to keep it current.

The Video Letter

People are too busy to sit down and write long letters so the telephone has replaced the pen as a means of regular communication between family members and friends separated by long distances. Another method of correspondence is videotape. A video letter provides a much more personal touch than a written note and it's a project the whole family can participate in.

Before you begin the taping session, have each member of the family plan what he or she wants to say and do.

Start off with a shot of the whole family in a group setting such as around the Christmas tree. From that, go to individual shots as family members "write" their personal portion of the "letter." Other settings for the video letter could be the pool, the backyard patio, the family room, even a scenic spot during a vacation.

The video letter is especially meaningful to family members who are separated by great distances. But, before you try to send a videotape to someone in a foreign country, be sure that country's TV and video system is compatible with the NTSC television system used in the United States. If their country uses a different system such as PAL or SECAM they won't be able to play your tapes, and you won't be able to play theirs.

There are some VCR's that will play videotape recorded in any TV standard but they are still very expensive. If you constantly exchange video letters, you could buy a camcorder and a small TV set of a foreign TV standard. Such a setup is also expensive but could be worth the money if used enough.

Video as a Coaching Aid

Take a camcorder to your kid's game and the coach will make you a valued member of the coaching staff if you're willing to provide the team with game video. Game video is simple to shoot:

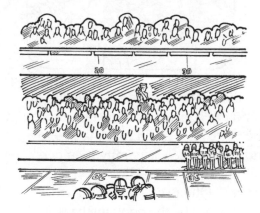

1. Find an elevated position behind the baseball diamond's home plate, near the center line of the hockey arena, or the 50-yard line of the football field.

2. For steady video and greater personal comfort over an extended period of time, use a tripod.

3. Generally, you should keep the zoom lens at or near its maximum wide-angle setting so you can keep the most of the action in the picture.

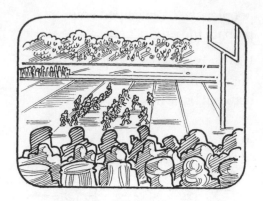

4. Roll the tape before the action begins and keep it rolling until the action is over. For example, in football, roll the tape as the team breaks from the huddle and pause it after the play-ending whistle. In baseball, roll the tape when the pitcher accepts the catcher's signs and pause the tape at the conclusion of the results of the pitch. And in hockey, roll the tape just before the puck is dropped for the face-off and pause the tape after the play has been whistled down.

There are times when the coach will want you to concentrate on specific aspects of the game or an individual player. The coach can tell you what view of the action will give him the best video.

Insurance Records

In the event of a fire or burglary, you'll find it virtually impossible to remember every little nic-nac and possession on the shelves, in the drawers, and in the closets of your home even if they've been there for years. In such cases, a videotaped record of your home could prove to be extremely valuable.

While a videotape of your possessions won't necessarily prove ownership, it will help you remember the easily forgotten things that could add up to a lot of insurance money.

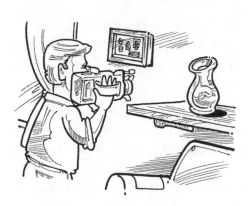

To make a videotape record of your home, shoot all the furniture and appliances and everything on the walls. Open

every drawer and make a shot of the contents. Don't forget the basement and the garage. Individual items of significant value, such as antiques, collector's items, and jewelry should be shot individually. A verbal description can be added as you shoot.

When you're completed with your home inventory tape, back it up with a written inventory and a file of receipts. Store the videotape, written inventory, and receipts in your safe deposit box so they won't be destroyed, or stolen with your other possessions.

Instructional Video

There's no better teaching aid than television. Students have been learning by watching TV for years. Some college courses are taught entirely by videotape, letting the student fit the class in at his or her convenience.

Business and industry are using TV to instruct, inform, and motivate employees. A growing number of companies have their own elaborate production facility and satellite network.

You, too, can use your camcorder as a teaching tool. For an example of an instructional video let's use a cooking class:

1. Organize your thoughts by writing a script or an outline. This will prevent a lot of stammering and stuttering when the cameraman rolls the tape and gives you the cue to begin.

2. Plan the production in three parts:

 a. The introduction including a description of the particular recipe and how it will be used in a meal.

 b. The instruction detailing the ingredients and how they are prepared and put together.

 c. The summary including the presentation of the finished dish and a taste test at the table.

3. Use wide shots to explain the overall kitchen setup and close-up shots to visually explain the details of preparing the recipe. You can repeat the steps that may be more difficult to understand.

4. Record the sound of the demonstrator as the presentation is made or you can add the commentary later.

Before attempting to shoot an instructional video, I would suggest you watch a couple of programs to see how the pros do it. By analyzing a professional how-to video, you can better determine what camera angles and verbal explanations are needed to make your production more effective.

Chapter Thirteen

The Main Thing — Have Fun With Your Camcorder

If you have tried my ideas and techniques as you read this book, there is no doubt in my mind that you have already seen an improvement in your home videos.

You may have purchased your camcorder just to record the important events in your family's life, or you have more ambitious projects in mind. Whatever, the overall goal is the same; to shoot more interesting and enjoyable videos.

The more ideas you try and the more you use your camcorder, the better your results will be. You can use the suggestions in this book as a springboard. Build on the basics and then experiment and develop a shooting style. Gradually, you'll discover what pleases you and what pleases your family and friends as viewers.

Read the Camcorder Instruction Book

This book contains practical information, based on my long years of professional experience, that you won't find in any camcorder instruction book. However, that doesn't mean you should throw away the manual. It, too, is a very important tool.

The manual tells you everything you need to know about the functions and operation of your particular model. Reading the manual will keep you from mis-using and possibly damaging your equipment, and it will complement this book in ensuring that your videomaking will be successful and fun.

Practice, Practice, Practice

As with most things worth doing well, videography requires practice. Get to know your camcorder well, and its operation will become second nature to you. Set aside a videotape just for practice to study the results you achieve.

It won't be long before you're making home videos that will truly impress your family and friends, and bring you a feeling of accomplishment!

Glossary:

Autofocus. Camcorder feature designed to focus the picture automatically.

Background. The area behind the subject.

Back lighting. Lighting behind a subject.

Camcorder. A one-piece combination video camera and video cassette recorder.

Camera angle. The angle from which a particular shot is taken.

Close-Up. View of a subject from a short distance.

Depth of field. The depth of the area in which objects in the frame will be in clear focus.

Dub. To electronically transfer contents of one tape to another.

Editing. Assembling a logical finished tape by recording selected pieces from other cassettes. This requires a VCR or another camcorder.

Fade in. A gradual transition from black (or white) to a picture.

Focus. Sharpening the clarity of your subject.

Focus ring. The ring on the lens used to manually focus a camcorder.

Hand-held (hand-holding). A method of supporting a camera without the aid of a tripod.

Jump cut. Abrupt transition from one scene to another similar scene.

Long shot. View of subject from a long distance.

LUX. A unit of light measurement.

Medium shot. View of a subject from the waist up.

Monopod. A one legged tripod, offers stability and greater ease of movement.

Pan. A horizontal camera pivot.

Scene. A particular segment of videotape.

Shot. Refers to the area seen in the viewfinder.

Subject. The man person(s) or object(s) you are videotaping; usually that which your camcorder is focused on.

Tripod. A three legged stand designed to support a camera or camcorder.

VCR. Video Cassette Recorder.

Viewfinder. Camcorder eyepiece used to monitor and frame video images.

White balance. A built-in system designed to enable adjustment for different lighting conditions.

Wide angle. A short focal length used to gain a wide perspective.

Zoom in. To change a zoom lens to a telephoto position; close-up.

Zoom out. To chance a zoom lens to a wide angle position; long shot.

Index:

Complete your videomaking library with these fine books from *Amherst Media*

Camcorder Tricks & Special Effects

Turn your camcorder into a toy! Camcorder Tricks and Special Effects includes over 40 tricks and special effects to show you how! With only a camcorder and a few simple props, you can simulate effects used by TV and Hollywood pros, the whole family can join in the fun—even Rover! Enjoy creating video fun, and make your videos an adventure to watch. $12.95 list, 7 x10, 128 pages, Stavros, order no. 1482

Features:

- No fancy equipment needed.
- Create wild transformations, animations, simulations, & more.
- Spice up home videos, presentations, and budget mini features.
- Make magic and develop silly skits.
- Entertain children, friends, and relatives.

"Your ticket to camcorder fun!"

– Steve Bryant, TV Host

Basic Camcorder Guide/
New Revised Edition

You won't believe the difference in your videos when you use this book! You won't have to spend hours studying, and you won't get caught up sifting through a lot of jargon and technical terms. For anyone who wants to take better videos. $12.95 list, 7 x10, 112 pages, Bryant, index, order no. 1239

Features:

- Use your camcorder to the maximum potential, whatever its format and features.

- Try out easy techniques that make any video look professional.

- Learn specific tips help you shoot better video of kids, pets, sports events, weddings, special situations, & more!

- Fully illustrated!

Get back to the basics and make great videos with the *Basic Camcorder Guide!*

See the next four pages for more books from *Amherst Media* ☞

Other Books from Amherst Media

Basic 35mm Photo Guide
Craig Alesse

For beginning photographer! Designed to teach 35mm basics step-by-step—completely illustrated. Features the latest cameras. Includes: 35mm automatic and semi-automatic cameras, camera handling, f-stops, shutter speeds, composition, and lens & camera care. $12.95 list, 9 x 8, 112 p, 178 photos, order no. 1051.

Build Your Own Home Darkroom
Lista Duren & Will McDonald

This classic book shows how to build a high quality, inexpensive darkroom in your basement, spare room, closet, bathroom, garage, attic or almost anywhere. Full information on: darkroom design, woodworking, tools, building techniques, lightproofing, ventilation, work tables, enlargers, lightboxes, darkroom sinks, water supply panels & print drying racks. $17.95 list, 8 1/2 x 11, 160 p, order no. 1092.

Into Your Darkroom Step-by-Step
Dennis P. Curtin

The ideal beginning darkroom guide. Easy to follow and fully illustrated each step of the way. From developing black & white negatives to making your own enlargements. Full information on: equipment you'll need, setting up the darkroom, making proof sheets & enlargements, and special techniques for fine prints. $17.95 list, 8 1/2 x 11, 90 p, hundreds of photos, order no. 1093.

Camera Maintenance & Repair
Thomas Tomosy

A step-by-step, fully illustrated guide by a master camera repair technician. Sections include: general maintenance, testing camera functions, basic tools needed and where to get them, basic repairs for accessories, camera electronics, plus "quick tips" for maintenance and repair of specific models. $24.95 list, 8 1/2 x 11, 176 p, order no. 1158.

Make Fantastic Home Videos
John Fuller

All the information beginning and veteran camcorder owners need to create videos that friends and relatives will actually want to watch. After reviewing the basic equipment and parts of the camcorder, this book tells how to get a steady image, how to edit while shooting, and the basics of good lighting and sound. Sample story boards and storytelling tips help show how to shoot any event right. $12.95 list, 7 x 10, 128 p, fully illustrated, order no. 1382.

Camcorder Tricks & Special Effects
Michael Stavros

Turn you camcorder into a toy! Over 40 tricks and effects show you how. With only a camcorder and simple props, you can simulate effects used by Hollywood pros. Each trick tells what you'll need, and shows the simple steps to getting the effects you should. It's so easy, the whole family can join in the fun — even Rover! Enjoy creating video fun, and make your videos an adventure to watch. $12.95 list, 7x10, 128 p, order no. 1482.

Basic Camcorder Guide/ Revised Edition
Steve Bryant

For everyone with a camcorder, or those who want one. Easy and fun to read. Packed with up-to-date info you need to know. Includes: selecting a camcorder, how to give your videos a professional look, camcorder care tips, advanced video shooting techniques, and more. $12.95 list, 6 x 9, 96 p, order no. 1239.

Infrared Photography Handbook
Laurie White

Totally covers infrared photography: focus, lenses, film loading, film speed rating, heat sensitivity, batch testing, paper stocks, and filters. Black & white and duotone photos illustrate how IR film reacts in portrait, landscape, and architectural photography, and how IR can create a dreamlike quality. Includes technical and artistic critiques of selected images. $24.95 list, 8 1/2 x 11, 104 p, 50 B&W photos, charts & diagrams, order no. 1383.

The Wildlife Photographer's Field Manual
Joe McDonald

The classic reference for the wildlife photographer. This complete how-to includes: lenses, lighting, building blinds, exposure, focusing techniques, and more. Special sections on: sneaking up on animals, close-up macro photography, studio and aquarium shots, photographing insects, birds, reptiles, amphibians and mammals., and more. Joe McDonald is one of the world's most accomplished wildlife photographers and a trained biologist. $14.95 list, 6 x 9, 208 p. order no. 1005.

The Freelance Photographer's Handbook
Fredrik D. Bodin

A complete and comprehensive handbook for the working freelancer (or anyone who wants to become one). Full of how-to info & examples, along with tips, techniques and strategies both tried & true and new & innovative. Chapters on marketing, customer relations, inventory systems and procedures for stock photography, portfolios, plus special camera techniques to increase the marketability of your work. $19.95 list, 8 1/2 x 11, 160 p, order no. l075.

Underwater Videographer's Handbook
Lynn Laymon

Accomplished diver, instructor and underwater videographer, Lynn Laymon, shows how to get started and have fun shooting underwater videos. Fully illustrated, with step-by-step instruction on: purchasing equipment, basic & advanced underwater technique, dive planning, composition & lighting, editing & post production, shooting underwater at night, marketing your new video skills, and much more. $19.95 list, 8 1/2 x 11, 128 p, over 100 photos, order no. 1266.

The Art of Infrared Photography
Joseph Paduano

A complete, straightforward approach to B&W infrared photography for the beginner and professional. Includes a beautifully printed portfolio. Features: infrared theory, precautions, use of filters, focusing, film speed, exposure, night & flash photography, developing, printing and toning. $17.95 list, 9 x 9, 76 p, 50 duotone prints, order no. 1052.

Big Bucks Selling Your Photography
Cliff Hollenbeck

A strategy to make big bucks selling photos! This book explains what sells, how to produce it, and HOW TO SELL IT! Paves the way for business success. Renowned West Coast photographer Cliff Hollenbeck teaches his successful photo business plan! Features setting financial, marketing and creative goals. Helps organize business planning, bookkeeping, and taxes. It's all here! $15.95 list, 6x9, 336 p, Hollenbeck, order no. 1177.

McBroom's Camera Bluebook
Mike McBroom

Totally comprehensive, fully illustrated, with price information on: 35mm cameras, medium & large format cameras, exposure meters, strobes and accessories. Pricing info based on the condition of the equipment. Designed for quick & easy reference; includes the history of many camera systems. A must for any camera buyer, dealer or collector! $24.95 list, 8x11, 224 p, 75+ photos, order no. 1263.

Guide to Photographing California
Al Guiteras

100's of the best photo opportunities in California! Listings rated with from 1 to 5 film canisters, signifying the overall image potential and the amount of film needed. Covers climate, local photo retailers & tips on shooting in difficult lighting conditions. $9.95 list, 6x9, 144 p, order no. 1291.

Write or fax for a *FREE* catalog
AMHERST MEDIA, INC.
PO Box 586
Amherst, NY 14226 USA
Fax: 716-874-4508

Video Notes

Amherst Media's Customer Registration Form

Please fill out this sheet and send or fax to receive free information about future publications from Amherst Media.

CUSTOMER INFORMATION

DATE

NAME

STREET OR BOX #

CITY STATE

ZIP CODE

PHONE ()

OPTIONAL INFORMATION

I BOUGHT *MAKE FANTASTIC HOME VIDEOS* BECAUSE

I FOUND THESE CHAPTERS TO BE MOST USEFUL

I PURCHASED THE BOOK FROM

CITY STATE

I WOULD LIKE TO SEE MORE BOOKS ABOUT

I PURCHASE BOOKS PER YEAR

ADDITIONAL COMMENTS

FAX to: 1-716-874-4508

Name_____
Address_____
City_____State_____
Zip_____ — _____

Amherst Media, Inc.
PO Box 586
Amherst, NY 14226